Shelter at the Shore

THE BOATHOUSES OF MUSKOKA

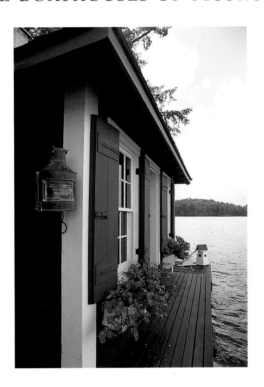

Shelter at the Shore

THE BOATHOUSES OF MUSKOKA

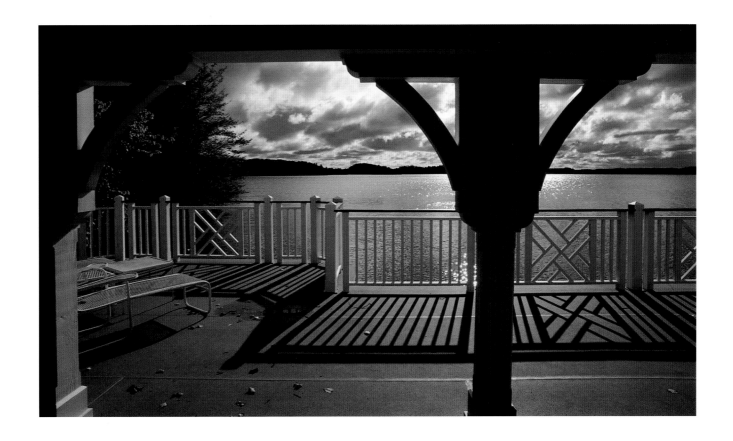

PHOTOGRAPHS BY John de Visser / TEXT BY Judy Ross

The BOSTON
MILLS PRESS

The authors would like to thank
all those who allowed us to photograph their boathouses in the midst of a rainy summer.

A BOSTON MILLS PRESS BOOK

Copyright © 2001, 2008 John de Visser and Judy Ross

Published by Boston Mills Press, 2008
132 Main Street, Erin, Ontario N0B 1T0
Tel: 519-833-2407 Fax: 519-833-2195
www.bostonmillspress.com

In Canada:
Distributed by Firefly Books Ltd.
66 Leek Crescent
Richmond Hill, Ontario, Canada L4B 1H1

In the United States:
Distributed by Firefly Books (U.S.) Inc.
P.O. Box 1338, Ellicott Station
Buffalo, New York 14205

The publisher gratefully acknowledges the financial support for our publishing program
by the Government of Canada through the Book Publishing Industry Development Program.

Library and Archives Canada Cataloguing in Publication

De Visser, John, 1930–
Shelter at the shore : the boathouses of Muskoka /
photographs by John de Visser ; text by Judy Ross.

ISBN 1-55046-345-4 (bound). — ISBN 978-1-55046-499-3 (pbk.)

1. Boathouses — Ontario — Muskoka — Pictorial works. I. Ross, Judy, 1942– II. Title.
NA6920.D48 2001 725'.87'0971316 C00-933210-3

Publisher Cataloging-in-Publication Data (U.S.)

De Visser, John, 1930–
Shelter at the shore : the boathouses of Muskoka /
photographs by John de Visser ; text by Judy Ross.
[144] p. : col. ill. ; cm.
Originally published 2001.

ISBN 978-1-55046-499-3 (pbk.)

1. Boathouses — Ontario — Muskoka (District municipality) — Pictorial works.
I. Ross, Judy Thompson, 1942– II. Title.
725/.87/0971316 dc22 NA6920.D42 2008

Design by Gillian Stead
Printed in China

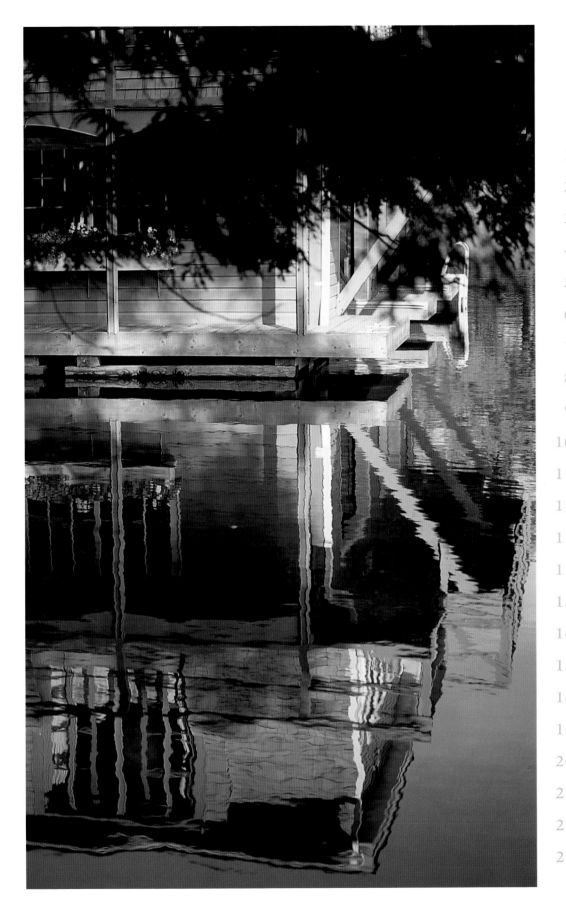

CONTENTS

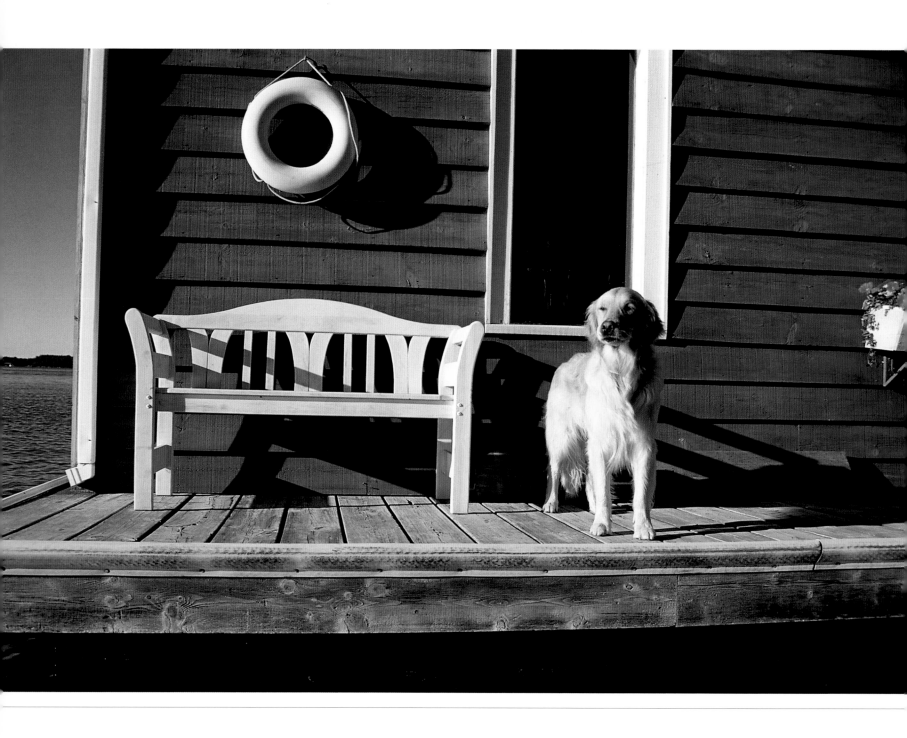

Christie, the Rosses' golden retriever,
offers an enthusiastic welcome at the boathouse.

Preface

We built our boathouse in 1988, not because our old tin boat needed shelter but simply because we needed more living space. Until then my husband and I and our two daughters had existed every summer in a two-room bunkie. The main cottage belonging to my aunt was across the wooden bridge on the other island.

The 1940s bunkie on its own mini-island had a certain rustic charm. Water lapped against the rocks on all sides and the lake was only a few long strides from the front steps. The interior had the exposed studs and painted planks currently in vogue, and the tiny screened porch captured every lake breeze. But we were hopelessly crowded in those two rooms, so we began to investigate our expansion options.

We originally intended to enlarge the bunkie, adding one more room. But Muskoka's building bylaws, long a source of mystery, would not permit. We could, however, build a two-story boathouse. We settled on the idea of building over water, conserving our tiny bit of land. Our main concern was how much living space we could fit within the walls — and since it was a boathouse, we did include a slip for the boat. We gave away the bunkie, moving it off the island and transporting it by barge to another property down the lake. That gave us a few more square feet of land as anchor for the boathouse. That winter the building began. Wooden cribs were lowered through holes in the ice and filled with rocks.

The deck timbers were nailed down in early spring. The walls were put up in a single day. We visited often.

I still remember being greeted by the sweet smell of freshly sawn wood. And the thrill of climbing a makeshift ladder to the second story to check out the view from what would become our sitting room. On each successive weekend the building evolved. One memorable sunny spring day we sat with friends on the new plywood subfloor, opened a bottle of champagne, and christened our boathouse-to-be.

If I had known then that I would later write not one, but two books about Muskoka's boathouses, I might have spent more time at the drawing board. Ours, though much loved and lived in, lacks the architect's touch. It evolved out of necessity, not whimsy. As such it has a Quaker simplicity.

Most important, our boathouse has fulfilled its function as a family cottage. We love living in it, watching the lake waters swirl around us. Our times there feel buoyant, as the light and water seep into our souls. On sunny days, sparkles dancing on the lake reflect on our walls and windows. And at night there's no better lullaby than the sound of waves lapping beneath the cribs.

After all these summers spent wrapped in blue lake at our boathouse, I understand why Muskoka cottagers want to build these houses on the water. They're much more special than houses on the land.

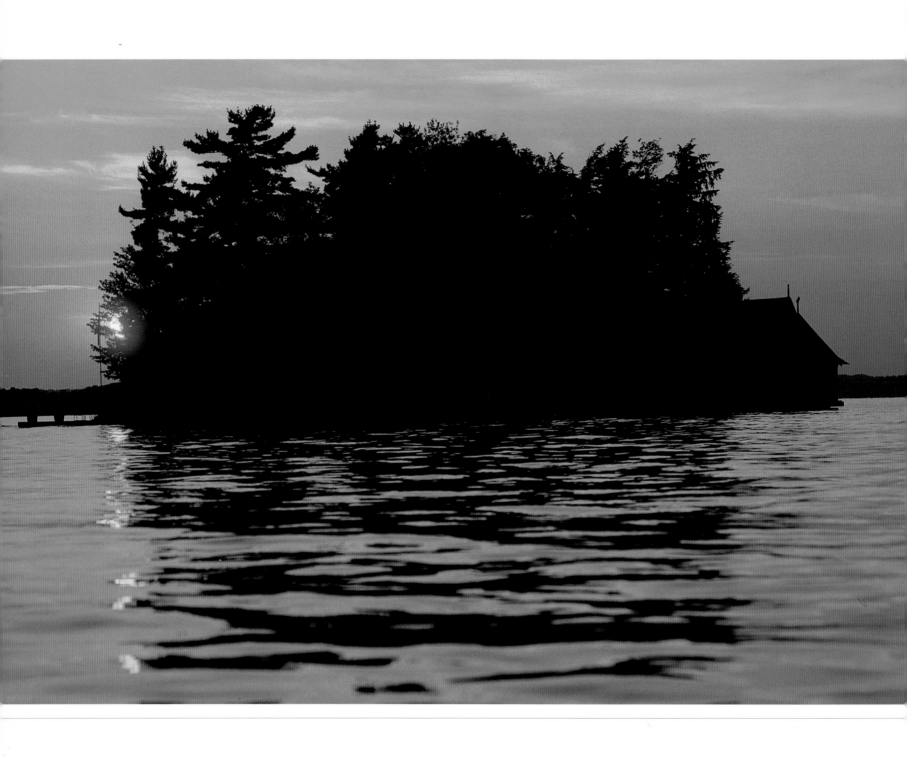

Foreword

D A V I D G I L L E T T

Rare is the building that seamlessly weds form and function. Castles do perhaps, and barns, and those brilliant white churches that dot the green hills of New England. Their beauty lies in the clarity of their mission: they are eloquent statements of function.

For my money, boathouses do it best: a door onto the lake just the width of a boat, a sheltering roof just big enough, a cabin for the captain up high enough to see the gathering clouds. Beauty in simplicity, elegance in honesty.

And yet, a twilight cruise on a July Lake Rosseau brings out the notion that there is much more to these whimsical structures than a simple equation of form following function.

As this book so beautifully illustrates, boathouses are individuals and as such are prone to the same foibles, the same strengths and the same complexities of character that individuals are. They are quirky, sometimes awkward, a strange roofline here, an oddly shaped door there — only later do we learn that it was enlarged to accommodate the newest darling in the family's fleet. They are babies on the architectural size scale and, like babies, are often the most pampered, most fawned over, and front and center at family gatherings. They wear architecture's equivalent of summer clothes: fun, comfortable, unpretentious. And they have, above all, memory. Memories of summers long past, memories of last month's regatta, of yesterday's quiet evening.

I spent a long afternoon in an old boathouse, originally built on the eve of the First World War. Grooves in the docks, worn slick as rubbed ebony, told of many summers of ropes and knots. Casual mementos laced through the hoist beams above me: old paddles, moth-eaten sails, gnarled sticks found floating, old bumpers. The place smelled of two-stroke premix and old cedar, warm dock boards and sunblock.

In the humid shadows of late July, ghosts lingered. Grandfather, a captain of industry in Pennsylvanian steel, had been one of the first to use steel girders to hoist his mahogany launch. Auntie was three-time cross-lake swimming champ. Brother had lost a new outboard engine on the shoal near Echo Rock. Every story, embellished a little with passing summers, originated at the boathouse, as if the grand old cottage was nothing more than a backdrop, a necessity that allowed life at the shore to go on.

Boathouses are like that. They gradually become little jewelry boxes of memories, repositories of the greatest family treasures and traditions, icons of summer life.

We are more ourselves at the lake, speaking more slowly, relaxed enough to savor the things that so easily pass by in the cacophony of modern life. We can pass the evening saying hardly anything at all, just listening to the water gently lapping and gurgling through the rock and timber cribs below the docks, the old tin boat gently thudding its hollow rhythm while somewhere across the lake children splash and carry on.

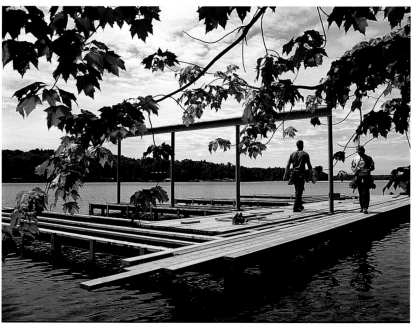
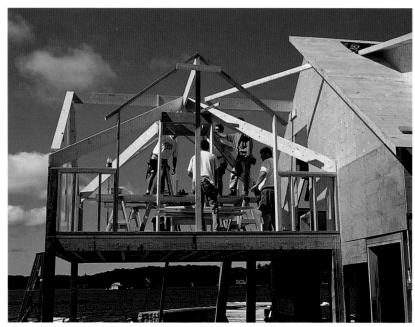
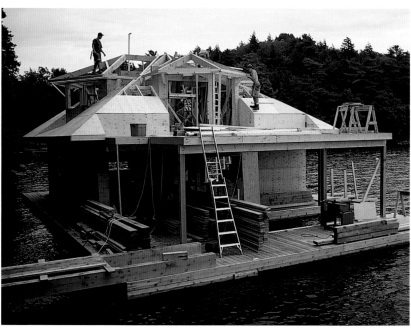

Peter and Claire Newton's boathouse under construction at McArtiff Point on Lake Joseph.

We could be anywhere in the world, I suppose, but we are here, at the cottage, down at the lake on the boathouse dock.

Architecture school hardly prepared me for the challenge of boathouse design. The great architectural heroes had nothing to say about slip length or cedar roofing. Corbusier, that brilliant French practitioner of modern architecture, while he would have enthused about a building floating above the water with a sleek launch in the bottom half, never did a boathouse project. Poor Corbusier! Boathouses are buildings on the fringe, structures that defy categorization, objects hovering on the margins, a few inches above water, a few feet off shore. He would have done a brilliant one.

On the other hand, some of the most charming boathouses have never been orchestrated by an architect, never felt a designer's touch, never been subjected to an engineer's keen scrutiny. Many are organic works in progress, pieced together by family collaboratives, the result of late-night planning sessions finally brought to life with the help of an able carpenter midwife.

Boathouses are centerpieces of family summertimes, and the designer tampers at his peril.

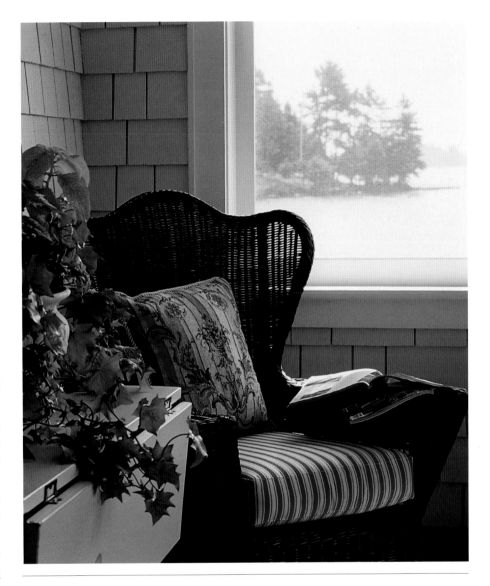

I often find myself part of a family circle, engaged in a heated discussion about the fate of an ailing old boathouse. Sometimes, it's almost like a painful discussion about what to do with Grampa now that he can't look after himself. A nursing home? No one likes to tamper. No one wants to tell him what to do . . . and so they turn to the doctor.

But I'm often unsure of the most effective treatment myself. A new coat of paint won't help much, but demolition? Never. And when we finally get around to talking about what the family needs and what the boathouse can do for them, things often fall happily into place. After all, Grampa may be ailing, but he's still Grampa. He just needs tender care, and where would the family be without the stories he can tell?

The cottage is to many people what the family farm was to earlier generations. Now that we are a culture of nomads, following jobs and opportunity to wherever, it is often the

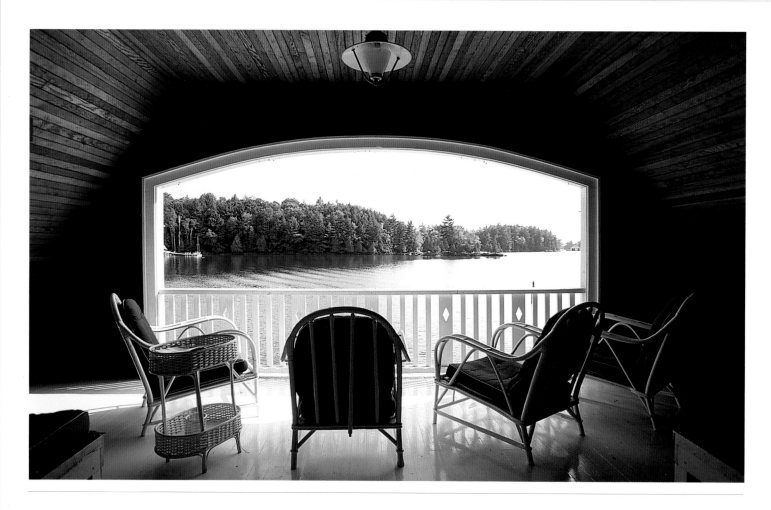

only geographic constant in our lives. Year after year, everybody congregates there, again pulled back by the memories of the place, by the promise of family reunion, by the same old rocks, the same dock, the same old quiet evenings on the boathouse deck, the same seductive sleep over the gently clunking boats that rock rhythmically in the darkness below our bed, that same single stream of moonlight falling, as it always has, on that same small sliver of ancient basswood wall.

Boathouses, even the mere thought of them, have a mesmerizing effect. I recently met with a client in New York, high above Fifth Avenue on a bleak day in November. When the photos of the lake fell out of the file and the drawings for the new building were unrolled on the boardroom table, the atmosphere was all Muskoka and cedar and and summer sun. Gray Manhattan faded into oblivion. For an hour, the little building on Lake Rosseau loomed larger than the Empire State Building, which was just visible over my shoulder.

But that's what boathouses do, especially boathouses like the ones on the pages of this book. They loom large on our summer horizons out of all proportion to their actual size.

They are little jewels of buildings that give shelter at the shore. And a whole lot more besides. Prepare to be mesmerized.

David Gillett
February 2001

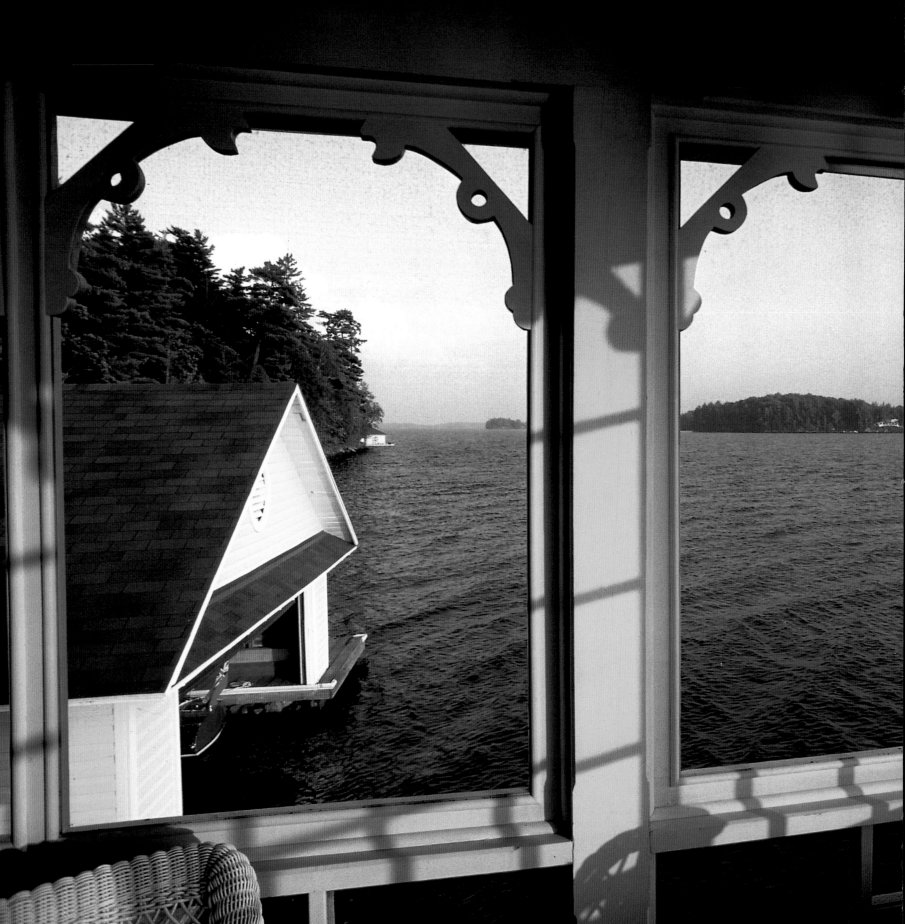

The Willardby porch —
as close as you can get
to living on the water
without being in a boat.

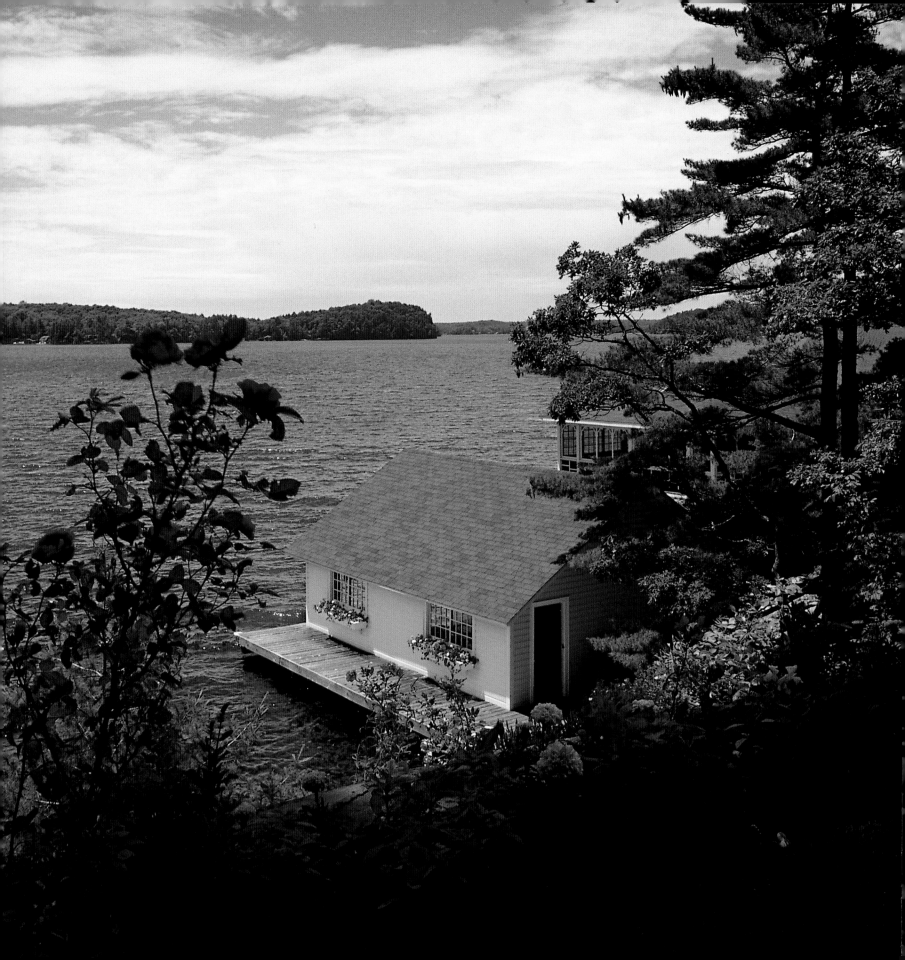

WILLARDBY

LAKE MUSKOKA

In the early 1880s, when Dr. Lewis Willard, a family physician from Pittsburgh, came to Muskoka on a fishing expedition, he fell in love with the Beaumaris area on Lake Muskoka. Because the air was so clean and free of pollen, he began to prescribe the resort area to his patients who suffered from hay fever. Before long Beaumaris became so crowded with these Americans that it was dubbed "Little Pittsburgh."

Dr. Willard spent several years as a guest at the Beaumaris Hotel before purchasing a lot on Tondern Island in 1889. He then built a two-story board-and-batten cottage on the brow of a hill and soon after, a boathouse. Both are still standing today — the property all recently restored and beautified by new owners and called Willardby in honor of the original owner.

The restoration was done by contractor Wayne Judges, a specialist in Muskoka heritage properties. Although the buildings were in very poor shape, they hadn't been altered in any way, which was a blessing. In reconstructing the boathouse, they were restricted by the small size of the original and the proximity of the next-door neighbor's boathouse. "Wayne is very good at finding solutions," says the owner. "We wanted to maximize the space but still maintain the look of an old boathouse. Some of the new ones seem to me to be far too playful and have little to do with early boathouse architecture."

Today the restored boathouse is a lemony yellow with graceful white trim. What had been a sort of plain Jane building is now rather fanciful. The screen porch is new, constructed above what had been an open flat roof. Now it's a favorite place to lounge in comfortable old wicker chairs. "If you move to the very end of the screen porch," says the owner, who comes from Switzerland to spend the summer at his Muskoka retreat, "you can watch the sunset over the lake." Details such as trim, window styles and lighting were chosen to tie together the boathouse and the vintage cottage. The gingerbread around the boathouse porch screens replicates the trim that surrounds the cottage porches. At night, when the lights glow from within and old-fashioned outdoor lamps spill gentle pools of light along the dock, the boathouse is especially pretty.

The upper level has a small bathroom and one large bedroom furnished with only the barest necessities. New windows slide across on gliders and sport fresh white curtains on simple iron rods. Basswood-lined walls replaced the original pine boards. "We wanted to save the old wood paneling," says the owner, "but animals had been nesting in the roof and the smell was impossible." The room seems spartan compared to the more lavish interior of the cottage but it's still a favorite with guests. Even the owners admit, "We sometimes go down and sleep in the boathouse just for fun."

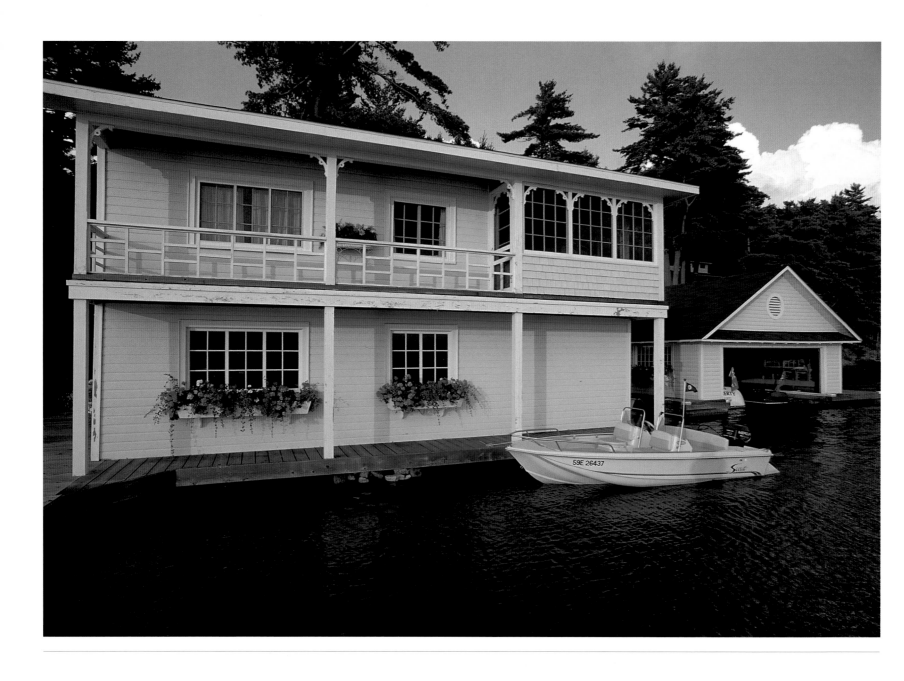

Willardby, one of Muskoka's classic old properties. There's a rambling cottage on a hillside with a spill of sunny garden out front. At the water's edge a pair of boathouses sit side by side. One is a 1960s addition, built to house two boats; the other, which dates back to the late 1800s, was altered to include a fanciful screen porch and a covered deck.

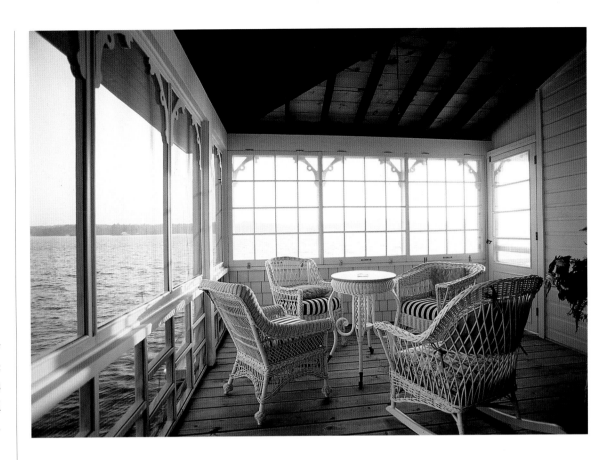

As protection from gusty lake winds, one end of the screen porch has glass windows that pull up and hook onto chains.

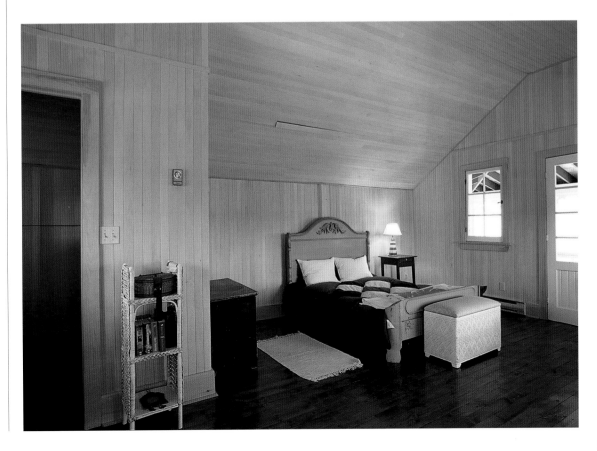

The boathouse bedroom is refreshingly simple. The wooden floors were restored and new basswood lines the walls.

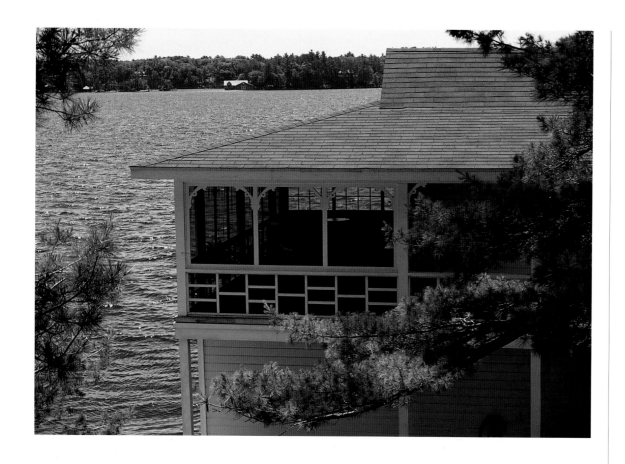

"All our guests want to sleep here instead of the cottage," says the owner of this boathouse, built in 1885.

The newer boathouse, constructed in 1960, accommodates only boats.

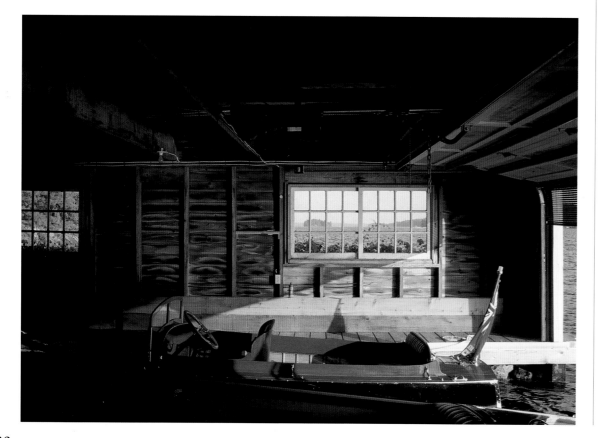

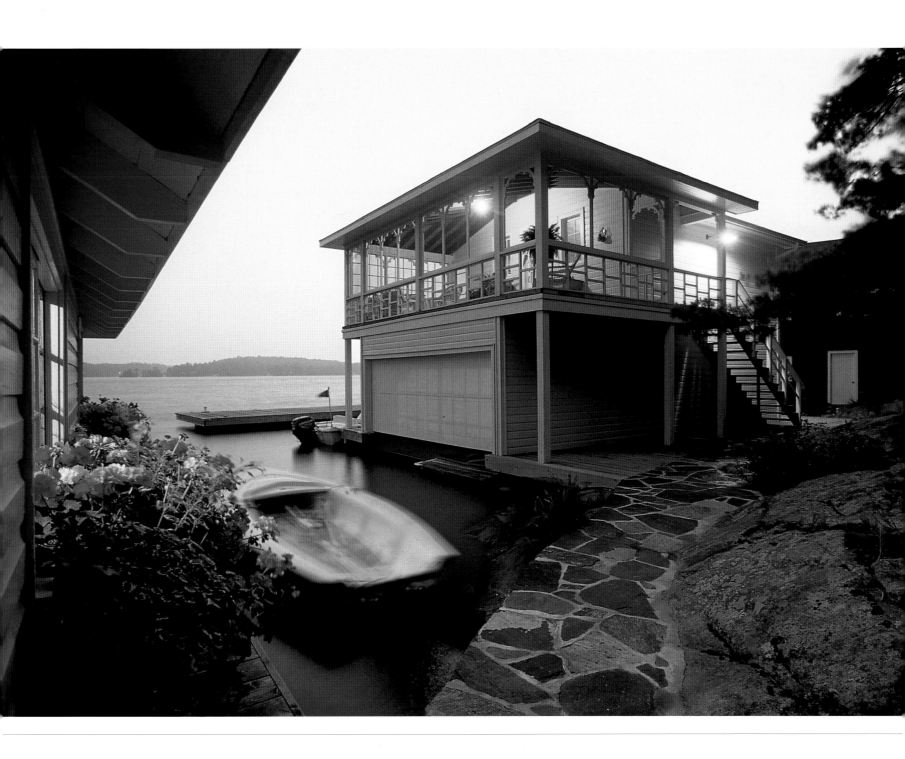

Dusk descends at Willardby.

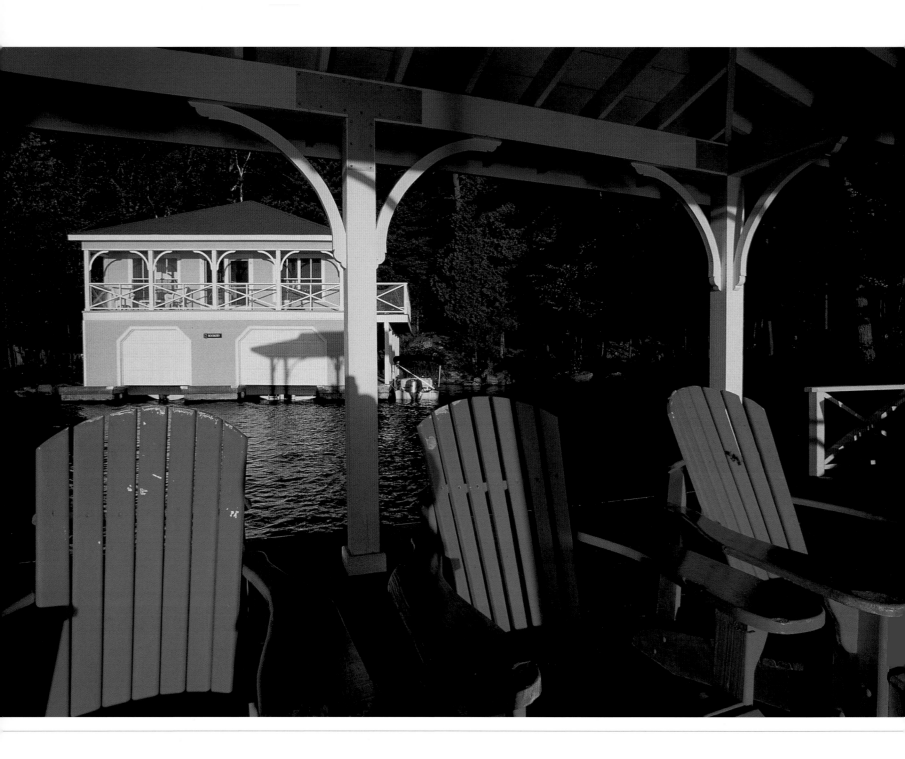

The Rookery boathouse from the dock.

THE ROOKERY

LAKE MUSKOKA

I t's known in the neighborhood as the yellow place with the neat row of red Muskoka chairs on the dock. When gusts of wind sweep across the point and carry away the red chairs, they always get returned, because people know where they came from.

The Rookery is one of Muskoka's great old cottages, built in the days of sleeping porches, deep gables and wraparound verandahs. The century-old cottage sits on a breezy point facing west across the lake. Now painted a sunny yellow, it was crumbling into ruin when Craig and Didi Hind bought the property in 1991. Working with builder Wayne Judges, they completely restored it, recapturing its traditional charm.

Between the cottage and a sleeping cabin, there was a single-story, flat-roofed boathouse settled in a protected cove. When Craig and Didi learned that three grandbabies were to arrive within six months of each other, they realized they needed more space. Adding a second story to the boathouse with room for the new parents and babies seemed like the best solution.

The Hinds worked together on the plans, poring over graph-paper sketches. The boathouse interior reflects their shared design ethic of spare simplicity. Both are firm believers that cottages should stay cottagey. "Why have a duplicate of a city home on the water?" they ask. And limited by the 650 square feet allowed in the boathouse, they wanted to use every morsel of space. "I was inspired by being on a boat last summer," says Didi, "and the space-saving measures I saw there." Work began in January, and by June they were ready to move in, baby cribs and all.

The boathouse interior has the feel of a sea-washed beach house, with rough-sawn plank walls painted white, and cherry-stained floorboards that can be easily swept clean. A screened porch spans the back of the building for al fresco dining in the treetops. And open decks surrounding two sides have plexiglass panels in the railings for child safety.

In the sitting room, a ship's ladder pulls away from the wall to provide access to an overhead loft, a clever way to add extra sleeping space.

"I consider practicality first," says Didi, "and then style." Indeed, the ingenious use of space in the two bedrooms is a testament to her philosophy. The rooms are small but not cramped, with windows framing watery views. The bases of the built-in queen-size beds feature drawers on castors. Closets hidden behind a curtain panel are spacious enough to store baby gear. And each bedroom has a crib tucked against one wall.

Working with Wayne Judges on both the cottage restoration and the boathouse addition has been a successful collaboration. "It's really important," says Didi, "to get a good builder like Wayne who can understand your ideas — and improve on them."

Both bedrooms are compact but comfortable, with built-in queen-size beds. Didi Hind made mobiles for over the baby cribs with twigs and starfish painted bright blue.

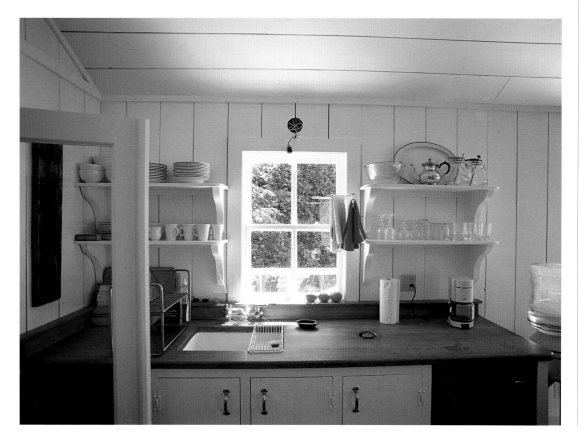

For the kitchen, Didi chose the unfitted look of open shelves and simple wooden cabinetry. Instead of filling space with a large refrigerator, she bought two bar fridges to fit beneath the cherrywood counter. Because the family is tall, the counters are higher than usual. The round cutout in the countertop is the lid for a garbage bin. Heavy chrome handles add to the cottagey appeal.

A ship's ladder pulls out from the wall and leads to the loft.

The walls are rough-sawn pine sheeting painted white. Builder Wayne Judges puts black felt paper behind the boards so that when they shrink, the cracks will show black instead of revealing the pink insulation. Even though boathouses are generally not used in winter, he insulates them to keep them cooler in summer and warmer in the off-season.

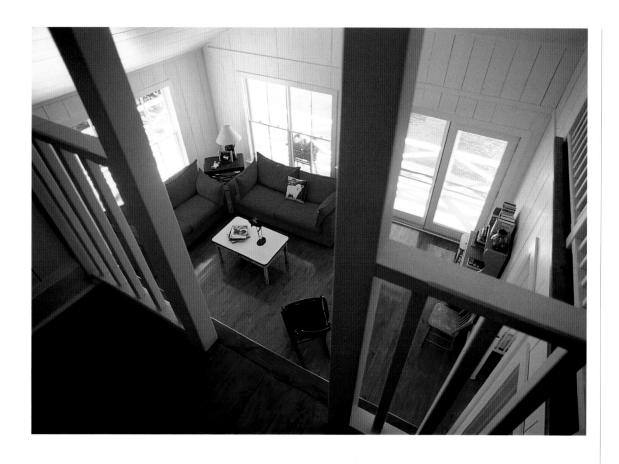

View of the living room from the loft.

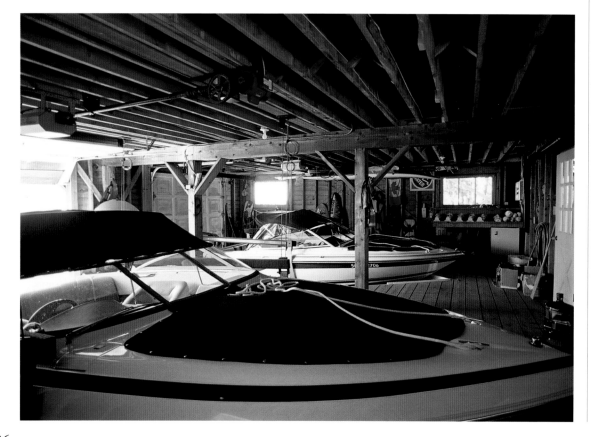

The original boathouse consisted of this space for boats and, above it, a deck on the flat roof.

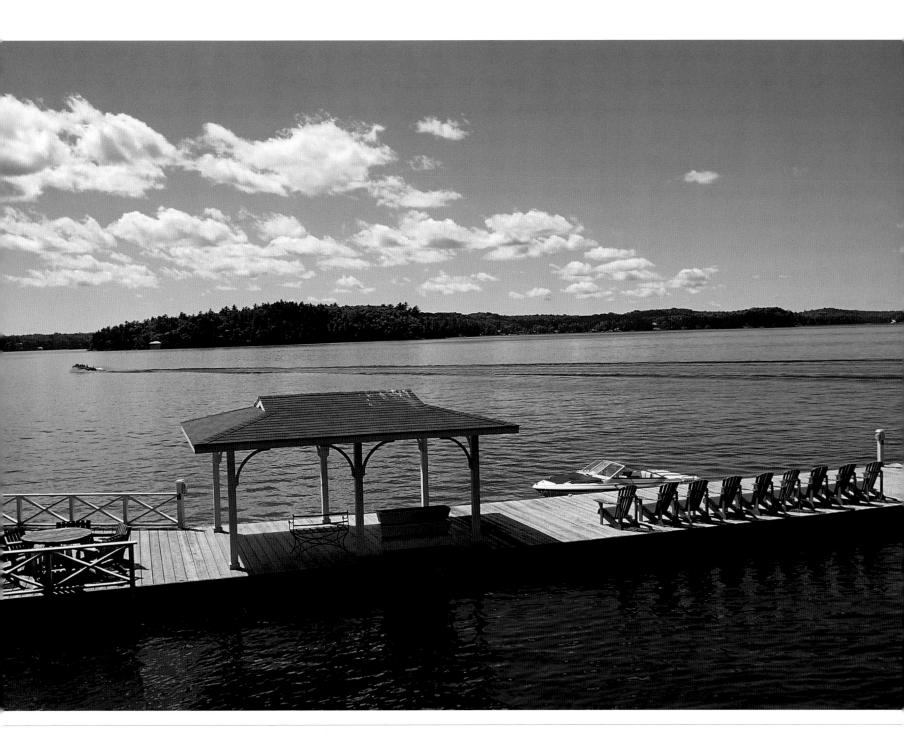

The view from the boathouse porch, facing west across Lake Muskoka.
The Hinds' eye for style and symmetry is seen in the orderly arrangement of dock chairs.

3

MONTANA LAGO

L A K E J O S E P H

One hundred and twenty-eight cedar stairs lead from the hilltop cottage down to the water at this Lake Joseph property. The cottage was built in 1987, the boathouse ten years later. "Building the boathouse was the best thing we ever did — it added a huge dimension of enjoyment," says Ewing Rae, who shares the waterfront retreat with his partner, Faye Clack. Before the boathouse, the trek down to the water for a swim seemed insurmountable at times. In fun, they named their property Montana Lago — Spanish for "mountain lake."

Ewing worked with Toronto architect Andrew Clark on the conceptual drawings of the boathouse and then handed them over to local builder Heath Billington of Lake to Lake Construction and Design. "We

spent a couple of years in the planning stages," says Heath, "and the boathouse changed form and position a few times." Priorities were to site it for the best view and privacy from the neighbors and to blend it with the cedar cottage on the hilltop. Another goal was to make it look substantial.

They chose one-by-eight rough-cut cedar for the siding and bulky two-by-four cedar for the trim. The dropped roofline with soffits just above the windows keeps the profile low, and the protruding deck breaks up the verticality. Heath's favorite term is "beefiness," and the sturdy design reflects that. He believes in punching up the details by using, for instance, thicker than normal trim around doors and windows. He also put up four columns instead of two on the outside deck canopy and chose pine roof shakes were chosen because they're thicker than the traditional cedar ones.

Faye spent a summer planning the interior in a sunny combination of yellows and blues. An enthusiastic cook, she put a lot of thought into the small kitchen, which is restricted by the boathouse building codes. She chose a propane stove, the quietest dishwasher on the market, and custom-made yellow and blue cabinetry. "We tend to entertain here at lunchtime when we can eat out on the covered deck," says Faye, "and for dinner we cook up at the cottage."

For Ewing and Faye, living on the water in a bedroom that faces east to the rising sun is pure pleasure. They both agree that the boathouse has changed their cottage existence. For one thing, they get far more sun down at the water's edge. "We positioned the building to make the most of a northeastern exposure," says Ewing, "I guess you could say we've made the best of a bad lot."

At the end of day when the sun is hitting the far shore, the setting is especially beautiful. "I love to sit out on the covered deck between five and seven on a summer evening," says Faye, "and just gaze across and watch the sunset colors on the far shore."

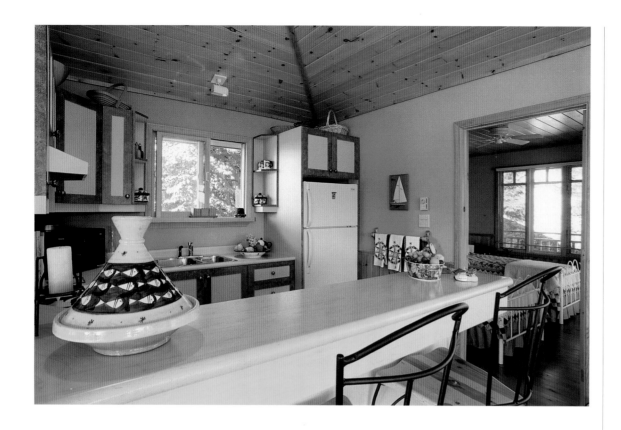

Small but efficient, the kitchen has a propane stove, dishwasher and microwave.

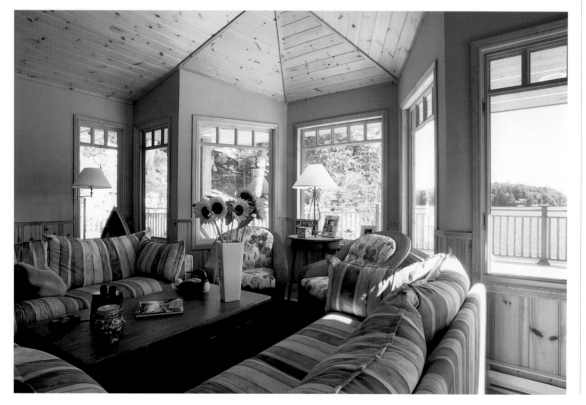

On sunny days, light bounces off the water into the cheerful living room. "Living on the water has given us a new perspective on cottage life," says Ewing Rae.

A contemporary take on traditional mullion windows
allows for a clearer view.

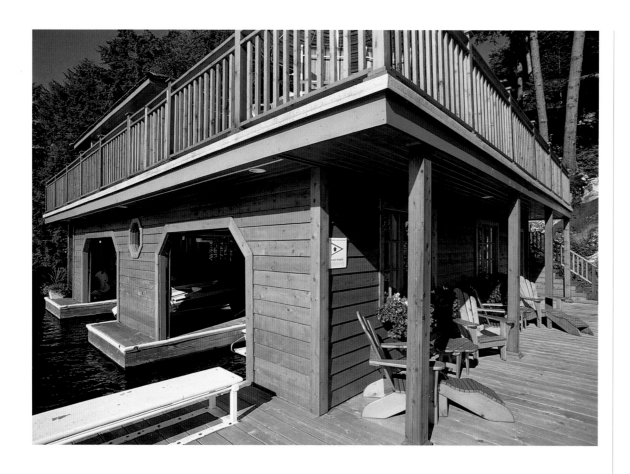

The kick deck surrounding the building breaks up the verticality. Builder Heath Billington believes that "if you're going to show a detail, then punch it out — make it attract the eyes."

Outcroppings of granite plunge into the lake at Ewing Rae's property. A cedar stairway scales the cliff between cottage and boathouse.

It's a long way from the cottage down to the boathouse, but worth the trip for the ever-changing views of lake waters.

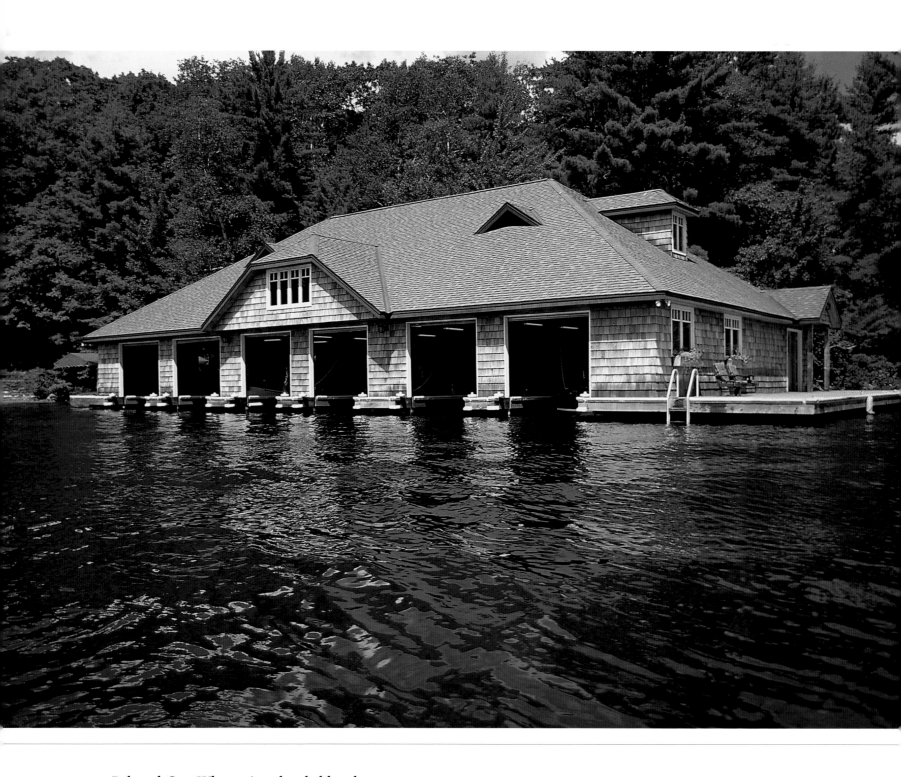

Bob and Gert Wharton's cedar-clad boathouse
was built specifically to house their antique boat collection.

THE SHALLOWS

LAKE ROSSEAU

The boathouse is huge, with six slips, each one housing an incredible antique boat. But somehow, despite its size, it blends into a quiet cove on the great swath of Lake Rosseau shoreline owned by Bob and Gert Wharton. They bought the 1,600-foot property in 1996 so that all four of their grown children could have their own cottage. Now that they have nine grandchildren as well, the property, with its sandy beach, tennis court and stone and cedar cottages tucked in the trees, could be mistaken for a summer resort.

In order to build a home for their antique boat collection, they first had to tear down an existing boathouse of the same size. Once the demolition was complete, the new building could begin. Working from a barge with a drill rig, builder Peter Ernst and his crew drove fifty six-inch-round steel beams into the bedrock at the bottom of the lake. Then the timber framing was laid according to the size and shape of the boat slips. Each slip was custom built to accommodate a particular boat.

This boathouse is strictly for boats. Clad in low-maintenance cedar shingles, it has no living quarters; the two fake dormers in the roof are strictly for appearance, to break up the massiveness of the roof. The tongue-and-groove (one-by-six-inch V-joint) pine interior is pristine, free of the clutter, not to mention cobwebs, usually found inside boathouses. Simple fluorescent tubes mounted on the pine ceiling provide lighting, and white ropes drop from ceiling rings and attach to chrome cleats to steady the boats in the water. Each boat is polished to perfection.

Usually, boats are pulled up in winter by pulley systems rigged to the posts and beams of the boathouse. But in the Wharton boathouse clear-span trusses hold up the roof without any support posts. Another solution had to be found to hoist the boats for winter storage. Bob and the builders devised a steel gurney system on wheels, which can be moved from one slip to another. The Whartons claim it's easier to pull boats out this way. When not in use, the rig is moved to the back wall of the boathouse.

Building this boathouse with clearspan roof trusses provided an added benefit that Bob Wharton didn't anticipate. He has the cleanest boathouse in Muskoka. Without posts and beams, there's nowhere for swallows to nest. "This was the best surprise," enthuses Bob. "We can leave the doors open and not worry about the birds — and there's never any bird dirt to clean up."

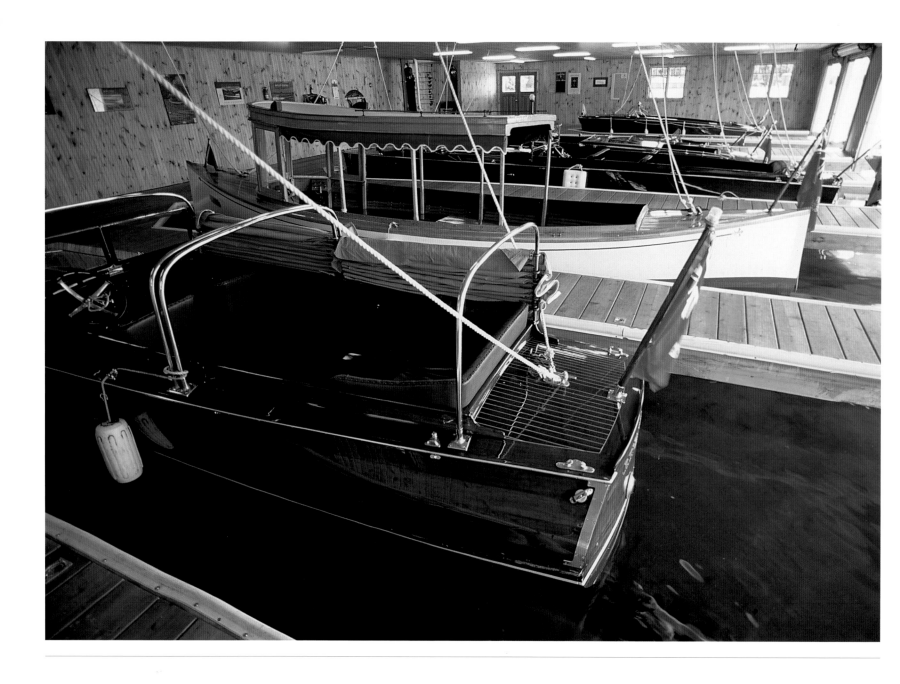

Inside the pristine building are some of Muskoka's finest boats: the *EL-MAR*, a thirty-two-foot Minett built in 1925 that won Best Boat in Show at the 1999 Antique & Classic Boat Show in Gravenhurst; a twenty-foot, 1952 Shepherd that has been in the family since the 1950s; a twenty-nine-foot Greavette Streamliner, the *Blueboy*, built in 1936; and Bob Wharton's most recent purchase — "I waited ten years for this one," he says — *Little Miss Canada II*, an eighteen-foot Greavette Gentleman's Racer originally built in 1933 for racing boat champion Harold Wilson.

The *Severn King* is the oldest boat in the Wharton collection. Built around 1900, it was used as a fishing boat on Georgian Bay. Her registration number, 25E82, means she was the eighty-second boat registered in the province of Ontario.

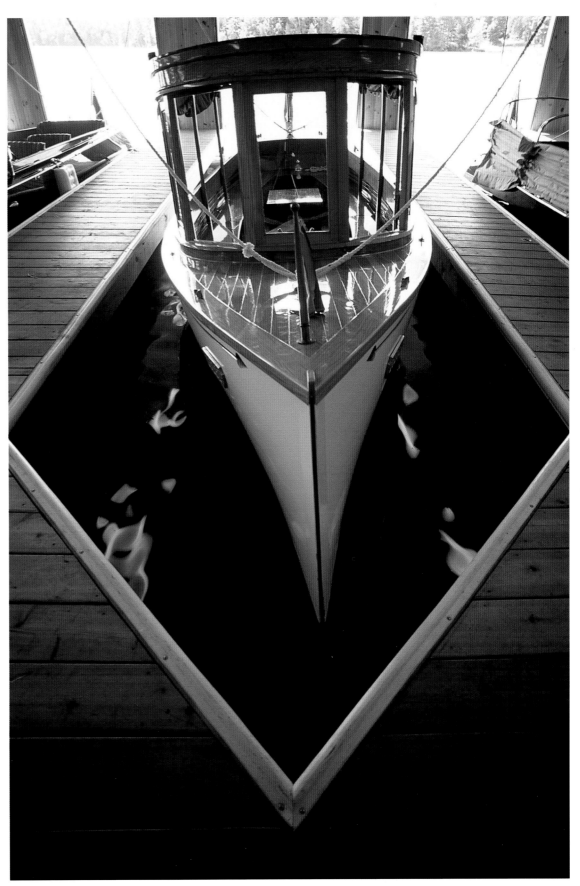

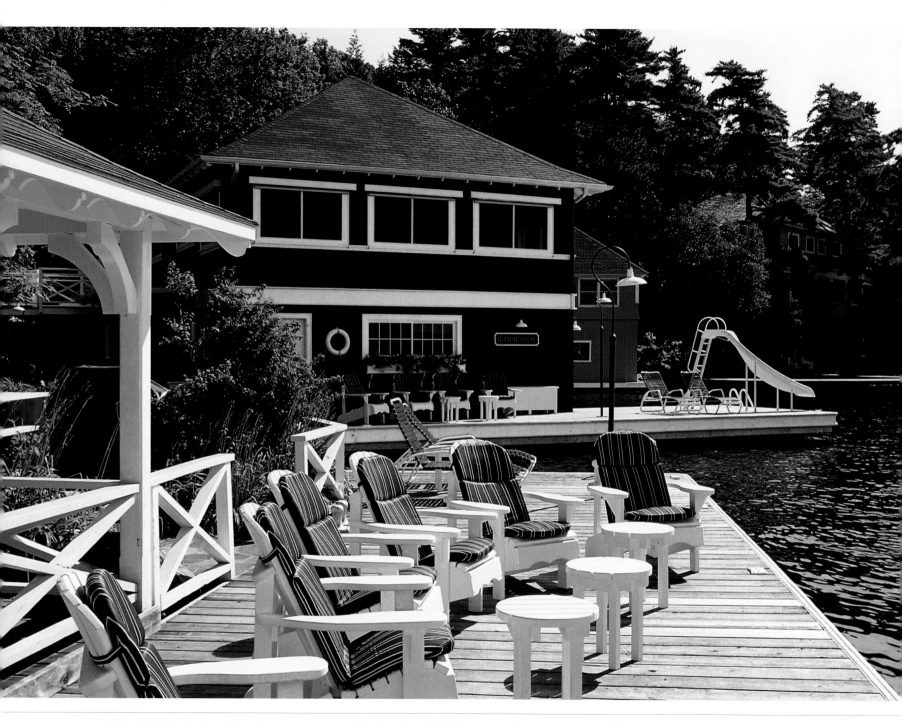

The Holiday House boathouse was completely rebuilt following a fire in 1999. Architect Tony Marsh worked from old photos to duplicate the original structure. "He understands the integrity of Muskoka architecture," says owner Lloyd Ross.

HOLIDAY HOUSE

LAKE MUSKOKA

The classic green and brown boathouse is a familiar sight on Millionaire's Row, the channel near Beaumaris most famous for its opulent cottages and boathouses built a century ago by wealthy Americans. Holiday House, with its sprawling cottage, hillside gardens, swimming dock and double boathouse, has been a focus of cocktail cruises for decades. But a keen eye will notice something different. The profile of the boathouse is the same, the materials and colors are the same, but it is a completely new structure. This boathouse was built after the original burned down in the winter of 1999.

"We built within the footprint of the original," says owner Lloyd Ross, "and, at the same time, we were able to make some subtle changes and improvements to the interior without altering the exterior envelope." The major change was creating one large boathouse out of what had been two buildings, circa 1905 and 1920. The two were separated at water level but joined by an upper-story enclosed walkway. The exterior facade still appears as two buildings, but inside, at water level, it's one vast space completely lined in cedar, with five boat slips instead of three. The orientation was changed so that all the doors face the lake, and the entire structure is supported now by one hundred and twenty steel beams drilled into four feet of bedrock.

Architect Tony Marsh, who has designed and restored many of the Beaumaris boathouses, approached this project with one main thought — "What more can I put above the footprint?" Working with the Kaye Brothers, builders from Milford Bay, he created living quarters that seem more airy and spacious, with peaks and beams in the ceiling and more elbow room in the hallways. "Instead of flat ceilings in the two main bedrooms, we put cathedral ceilings," says Tony, "and we expanded the dormers, which gives the illusion of extra space and light."

Furnishings were chosen to replicate the old wicker and Mission-style pieces that were lost in the fire. "I wanted to keep the old Muskoka look," says designer Margot Jarrett, who worked with Lloyd and Susan Ross on the basswood interior, "but with a fresher, lighter appearance. The main cottage is warm and textured with rich colors, so we wanted the boathouse to be a refreshing change." Margot blended reproduction wicker in natural dark colors with some old wicker pieces from the main cottage. She chose sun-faded fabrics for the "loose but not baggy" slip-covered sofas and chairs in the living room. The Mission-style dining-room furniture, made by Stephen Strand, a local cabinetmaker, is an exact copy of the original, which had been made by caretakers during the winter months. Even the kitchen looks as if it was created by local craftsmen back in the 1920s.

For the Rosses, working with Tony Marsh on the rebirth of the boathouse was a wonderful experience. "I still get goose pimples when I look at it," claims Lloyd. "It's as if nothing has changed."

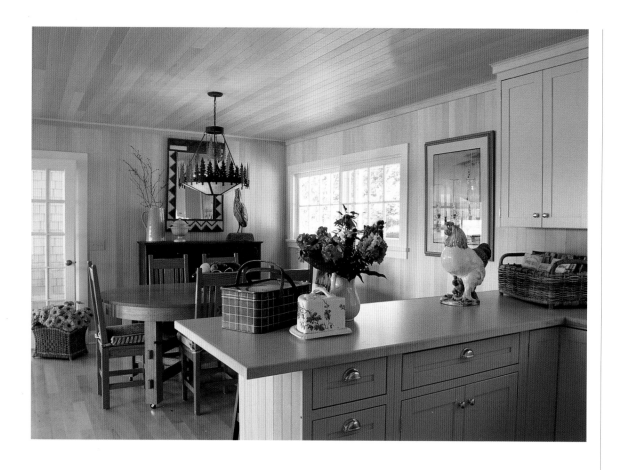

Details such as the brass binhandles in the kitchen are typical of the 1920s style. Back then, everything inside a boathouse was built on site by local talent. The dining-room furniture lost in the fire was replicated by local craftsman Stephen Strand.

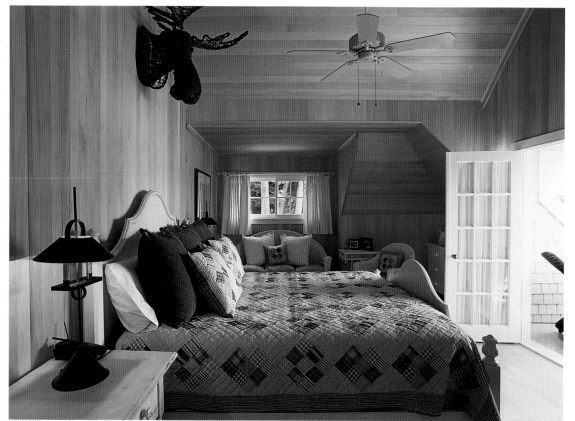

Two of the bedrooms have sleeping porches — an ideal place to enjoy cooling lake breezes. The "politically correct" moosehead is made of willow.

Antique binoculars and game boards occupy space in the country cupboard, which also houses a more modern diversion — a television set.

All the interior walls are lined in basswood, just as they were in the original building.

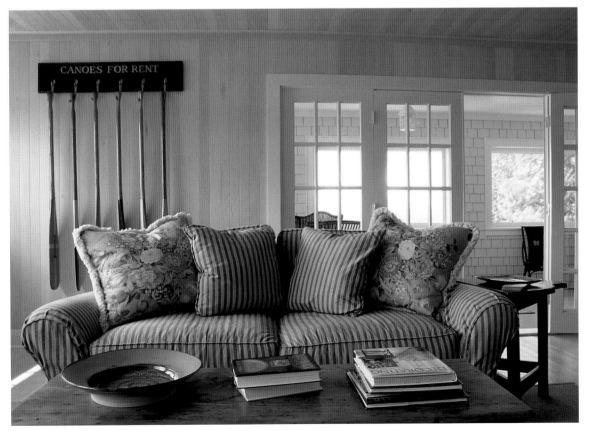

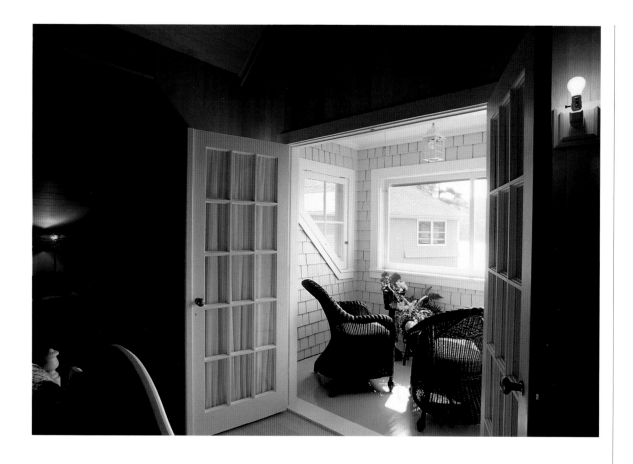

The reproduction wicker in the sleeping porch looks old. "I've gone back to dark natural wicker," says designer Margo Jarrett, "away from all white."

On hot summer days there's no better place than this screen porch off the boathouse living room.

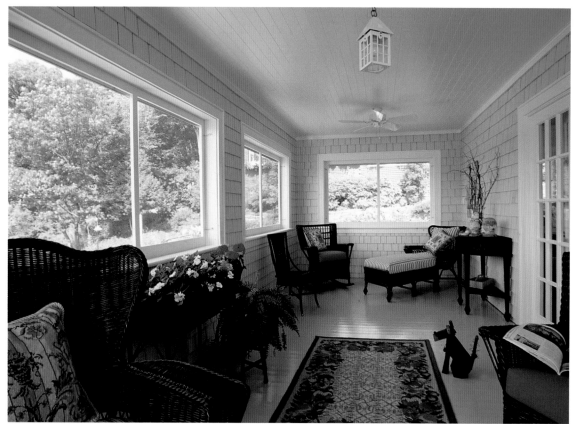

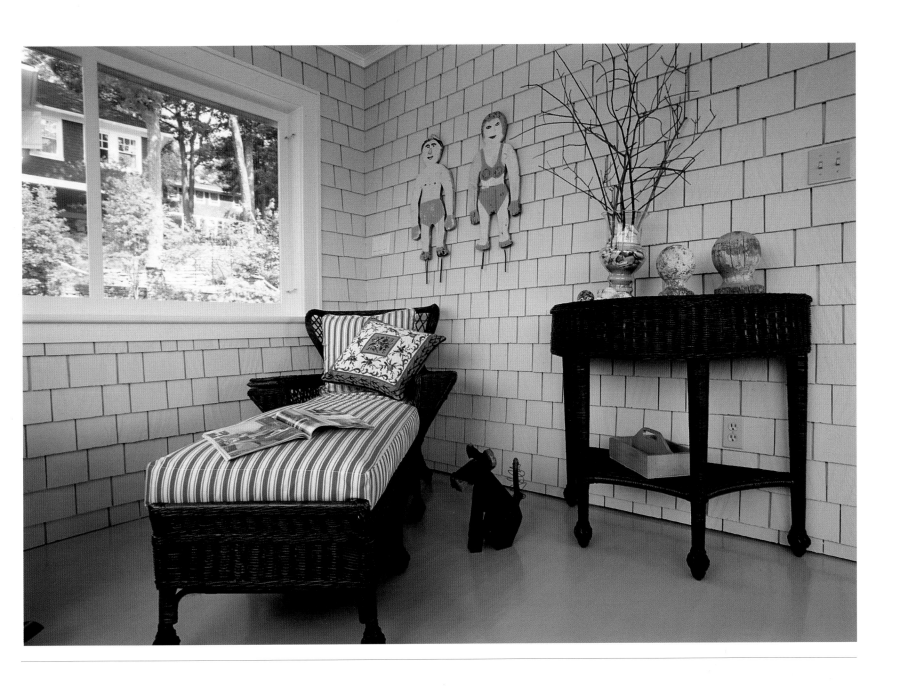

The shingles and floor in the screen porch were painted yellow to keep everything light and airy.
Electrically controlled translucent roll-down plastic shades protect the porch from rain and the prevailing west wind.

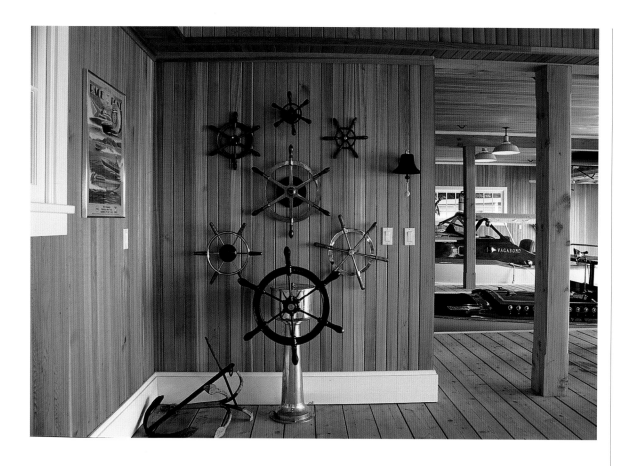

Completely lined in cedar, the interior has five slips and plenty of wall space for collections like this display of boat steering wheels.

The porcelain ceiling lights date back to the 1930s and came from a Pennsylvania factory. "I found fourteen of them at a flea market," says Lloyd Ross. "They were a great buy."

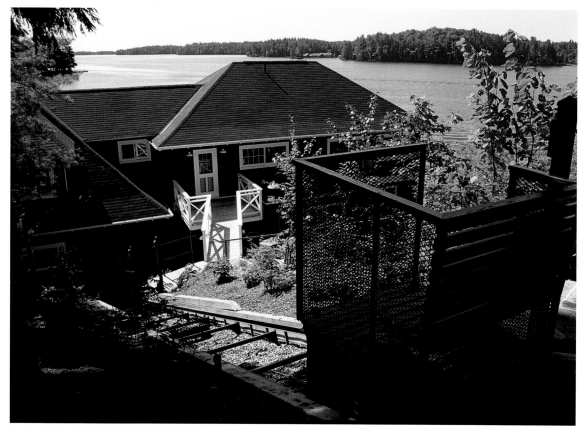

A hillside elevator built in the 1920s is still used to get from the boathouse to the large two-story cottage.

Builder Gary Kaye devised an underwater inertia baffle system to break the waves and protect the wooden boats. The *Vagabond*, a thirty-foot cabin cruiser, occupies one berth alongside the Rosses' 1928 Ditchburn, the *Princess*. "These boats are toys," says Lloyd Ross, "but we are preserving history. I hope, a hundred years from now, someone will be sitting in one of these and say, 'Thank goodness some old fool restored this thing.'"

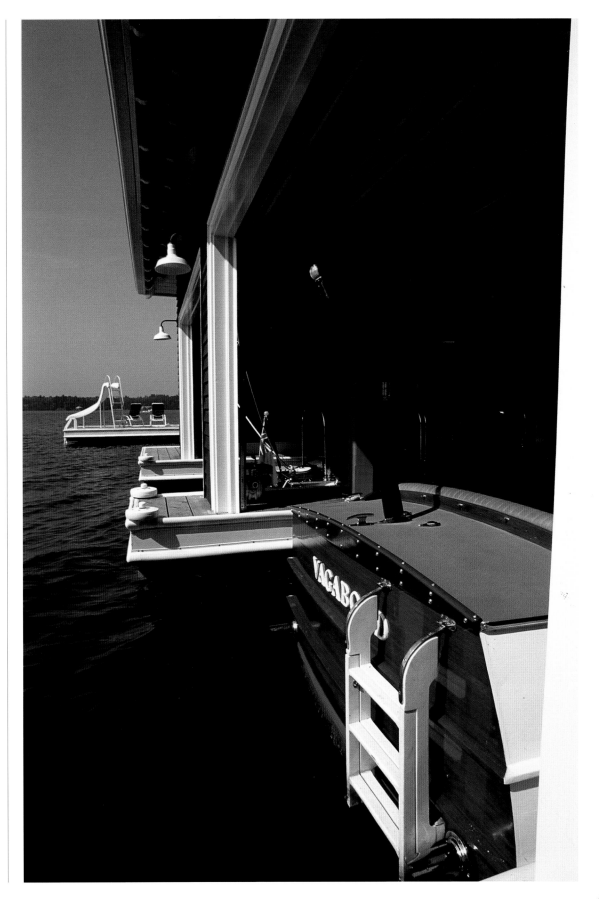

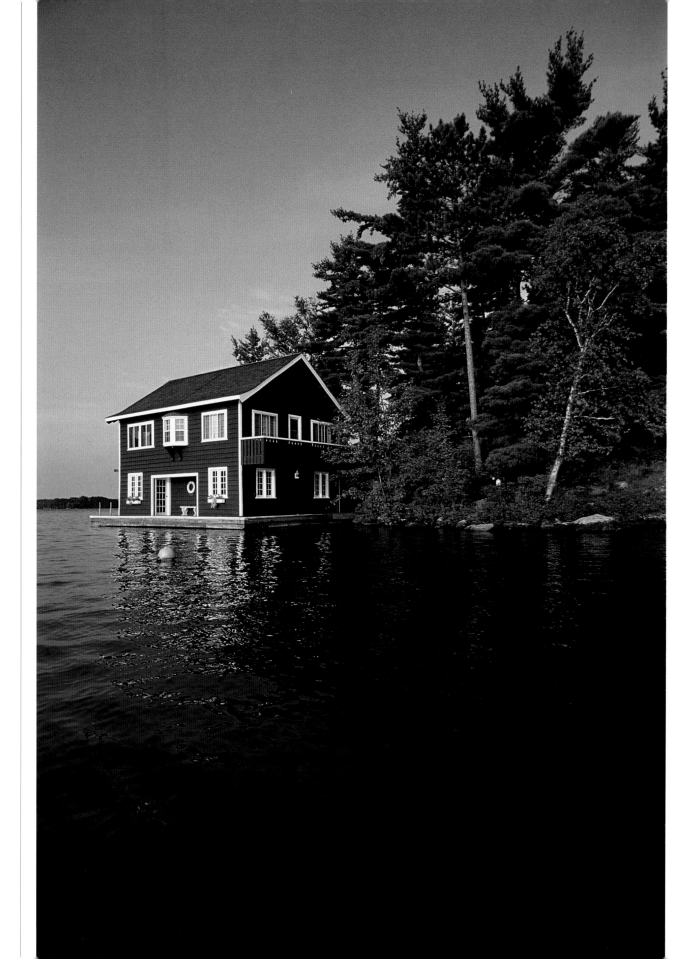

An eighty-year old boathouse finds protection on the leeward side of the island.

OWL ISLAND

LAKE MUSKOKA

Owl Island is a great escape and everything we love about summer," reads an entry in the guest book of this boathouse. Indeed, it is a charming spot.

There is no main cottage, just this three-bedroom boathouse and a small bathhouse. Both were built eighty years ago by the Saunders brothers from Bracebridge. They lived in a ramshackle miners' cabin on the island while the construction took place. Both talented builders, the brothers added architectural details such as bell-curved rooflines, angled rafters, and a unique stone fireplace that anchors the building. Their grandmother spent time on the island, too. She laid the wonderfully curved flagstone stairs and planted lily of the valley and peonies that still bloom every summer. At some point, the brothers feuded and the property went to one of their sons, a man who spent little time here.

Directly across the bay in a mainland cottage, Bev and Ann Collombin and their four sons had been summering for thirty years, looking longingly across at Owl Island and its brown and white boathouse. They considered it a treasure, a place unknown to many other cottagers on the lake, hidden as it is on the island's leeward side. They knew if it ever came up for sale they would want to buy it. In 1990, they did just that.

"We knew it would need some work," says Ann, "but it was in remarkably good shape considering its age." The first major job was to raise the level of the boathouse docks, which were all below water. They didn't want to mess with the stonework — the fireplace and archway connected to the island — so had to find a way to raise the dock level without also raising the boathouse. Ken Kaye, of Kaye Brothers in Milford Bay, first supported the building with jacks, then chain-sawed two feet off the base all the way around, creating an open skirt. Then, while the building was held steady on jacks, he added two feet to the height of the docks. Now, the only telltale signs are the doorways into the lower level of the boathouse, which have less headroom.

The Collombins went to work on the island as well. Bev cleared away debris, took down seven dead oaks, limbed other trees, and built a tent platform on a gentle rise behind the boathouse. Ann tackled the interior. "Everything in the kitchen was a ghastly pea green and yellow," she says, "so I stripped it all down and painted everything a cornflower blue." There was no bathroom inside the boathouse, so after installing a septic system, the Collombins added a small washroom in what had been the entrance hall. The new entrance is through a kitchen door off the back deck.

Today, friends and family use the boathouse. It's a remarkably peaceful place where light dances in the windows and the woody scent of an old cottage permeates the air. After a night's sleep on Owl Island, visitors often leave sweet thoughts written in the boathouse guest book.

Henry David Thoreau once wrote: "Even the tamest nearest island has a distinct character, unique, a place apart, existing in a state of grace outside the world." Owl Island is a window to such a place.

When Bev and Ann Collombin bought the island and boathouse, they painted the high-ceilinged kitchen in bold cornflower blue.

Sleep comes easily in bedrooms on the lake.

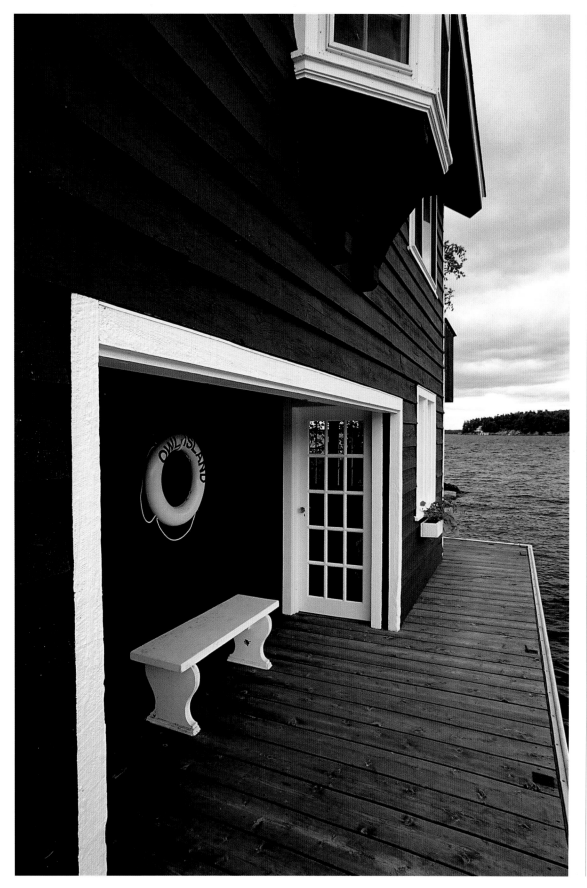

Framed black-and-white photographs in the living room show early days at Owl Island in summer and winter.

Almost yearly coats of Oxford Brown stain are required to keep the old clapboard from weathering.

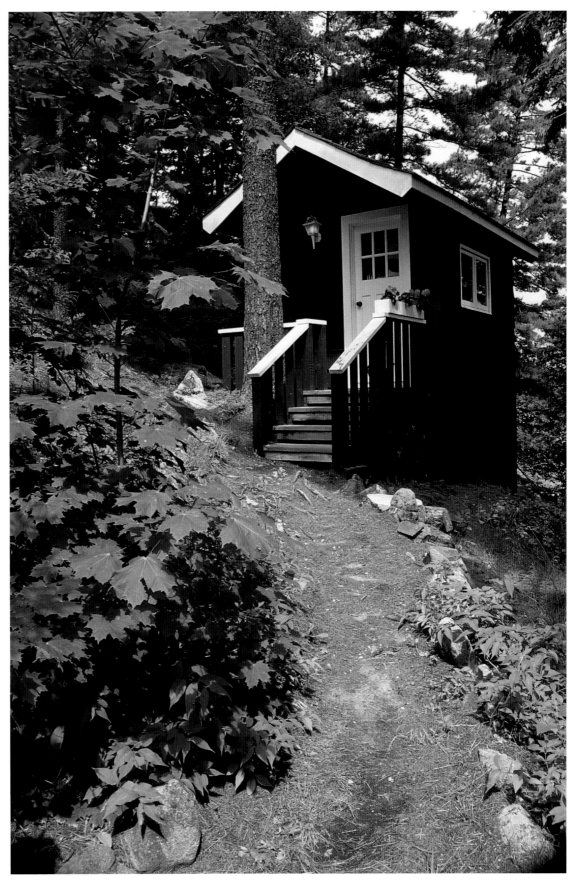

A bathhouse in the woods has a shower, sink and toilet and a dreamy lake view from the clawfoot bathtub.

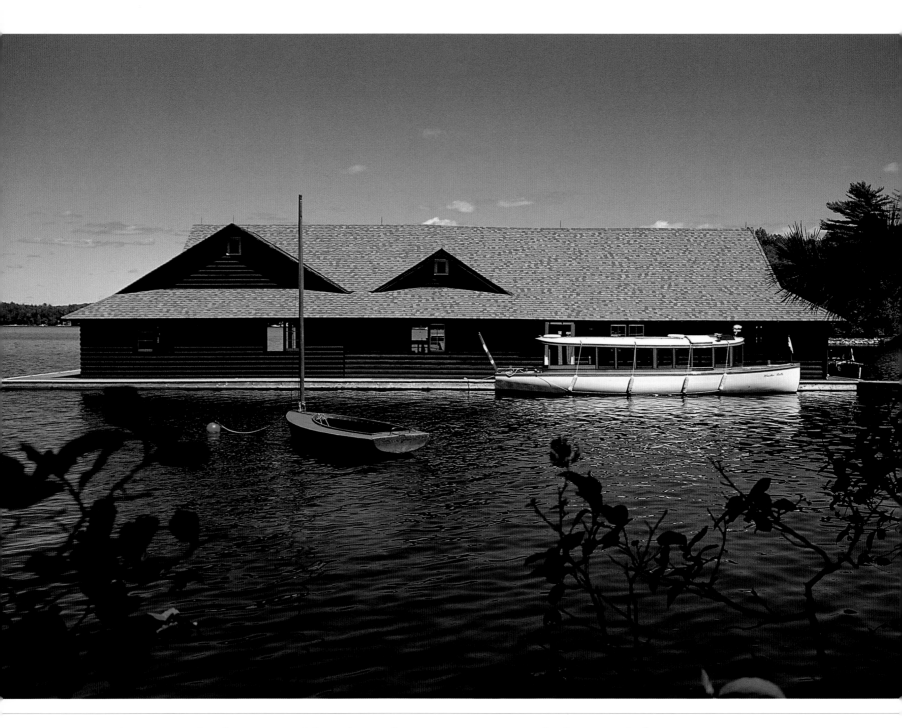

The Ferguson boathouse viewed from the gazebo on Norway Point. In the foreground, the antique
fourteen-foot dinghy built by Aykroyd Brothers in Toronto was a gift from the neighbors.
The flagship of Graeme and Phyllis Ferguson's fleet is the *Heather Belle*, tied at the dock.

7

NORWAY POINT

LAKE OF BAYS

Two hanging geraniums are the only attempts to fancy up the exterior of this dark half-log boathouse on Lake of Bays. It stands, protected from the prevailing west wind, in a bay at Norway Point. The property was once the site of the WaWa Hotel, a three-hundred-guest wooden-frame building that burned down in the summer of 1923. Across the bay is Bigwin Island and the eerily decaying remains of another famous resort, Bigwin Inn.

The boathouse, which is strictly for boats, was built in the 1930s in a subdued half-log design. In contrast, the sprawling stone cottage, which resembles a Scottish hunting lodge, was designed as a grand statement by Bigwin Inn architect John Wilson. It became the summer home of Frank S. Leslie, who owned Bigwin Inn from 1949 until the early 1960s. A lovely swath of green lawn spills down to the boathouse, expanded a few years ago from four to five slips. Inside is a bevy of beautiful boats.

Today, Graeme and Phyllis Ferguson, who own this historic property, live here year round. The boathouse shelters their treasured boat collection. As with any vintage boathouse, repairs and renovations are ongoing. The doors, for instance, were all crooked and had to be replaced. New lifts were installed by Ace Boat Lifts of Bracebridge for all the boats — even the thirty-six-foot *Heather Belle,* which required an industrial-size lift. "We wanted to be able to do it all

ourselves," says Graeme. "With this system, even Phyllis can put up all the boats on her own."

Their first purchase was the *Marie,* a twenty-six-foot Minett built in 1917, and that was when they "caught the bug." They have to stop now, say the Fergusons, because there's no more room in the boathouse. Their collection ranges from the sleek little Butson rowboat to the awesome *Heather Belle,* a generously sized cabin launch that was built in 1898 and came to Canada in 1902. At one time, she was licensed to carry twenty-two passengers on picnic outings from Thorel House on Lake Rosseau. She then spent some time at Santa's Village near Bracebridge, taking children on cruises up and down the river. The Fergusons bought her from the actor Donald Davis, who kept her at his Lake Muskoka cottage from 1971 to 1997.

"We love taking guests for cruises on the *Heather Belle,*" says Phyllis, "and everyone feels as if they're in an old movie, with the lace tablecloths and red velvet seat cushions." The interior, lined with mahogany paneling and furnished with the original wicker chairs, is like a Victorian drawing room. You might expect tea to be served on a silver tea service.

"No other cabin launch of this vintage has been in continuous use like this one," adds Graeme proudly. "The *Heather Belle* has never been unloved."

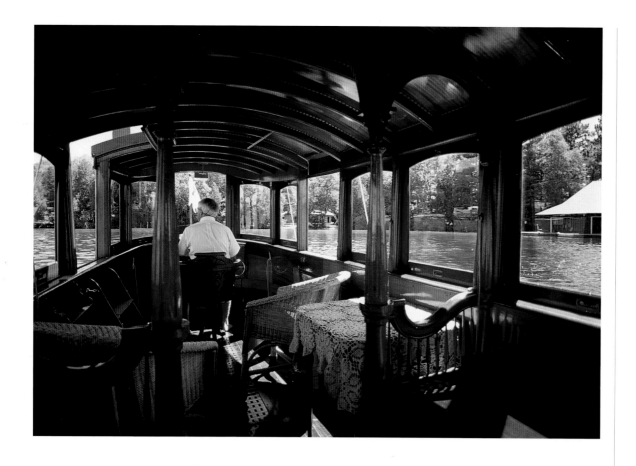

Heather Belle, a thirty-six-foot picnic boat, with its polished mahogany interior. An eight-horsepower electric system drives her at hull speed of eight knots.

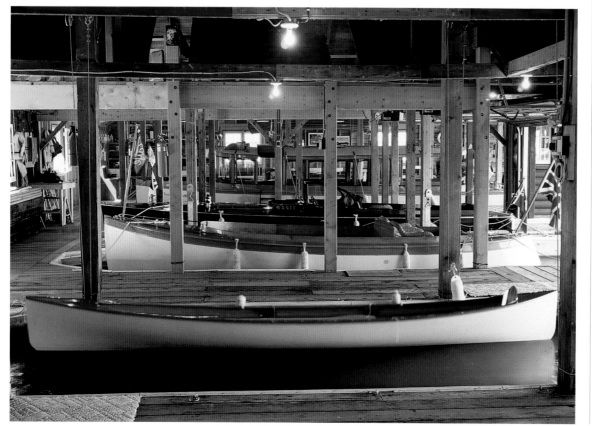

The original 1930s boathouse is home to a gleaming collection of antique boats. When Graeme bought *Heather Belle* he added an extra slip to accommodate her.

OVERLEAF:
Graeme Ferguson in *Marie*, a twenty-six-foot Minett built in 1917 and restored in 1985 by Butson Boats. Almost all the woodwork above the waterline is original.

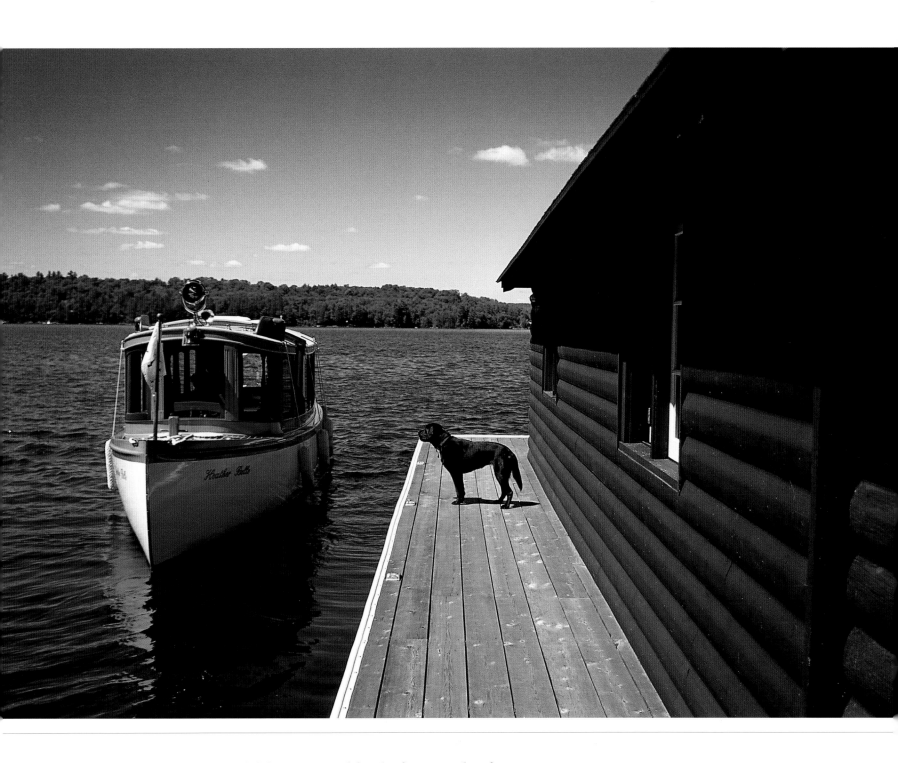

Naiad, the Ferguson's black lab, was named for the famous Lake of Bays steamer
once owned by Chicago milk magnate Cameron Peck.

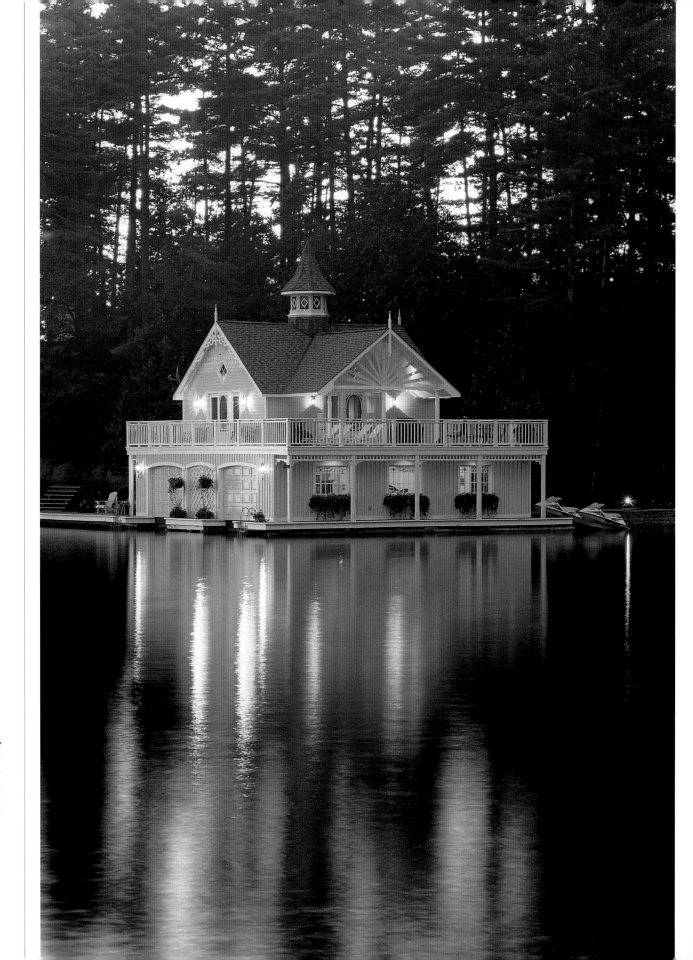

Golden rays of light spill from the boathouse onto the lake at dusk.

MONYCA ISLAND

LAKE ROSSEAU

For most island cottagers, the trip from mainland to island on a rainy day is a wet slog complete with soggy grocery bags. Few islanders have the luxury of a mainland boathouse where they can keep boats covered and ready to hop into when they arrive at the lake. That's what makes the mainland boathouse for Monyca Island so rare. Not only are the boats dry but you can drive a car right into the boathouse and step into the waiting boat. A garage door on the land side opens to the middle slip, which has a reinforced dock section for parking cars. On either side are boat slips, one holding a pontoon barge, the other a Shepherd cruiser. This is the unique welcome to Monyca Island.

Monyca was first settled in the late 1800s by the Watkins family. Their original log cabin, built in 1898, is still on the island, used now by owner Don Jackson as an office. The Watkins also built the huge turreted Victorian cottage just after the turn of the century. "I bought the island from the fifth generation of that family," says Don, "and ever since, I've been trying to restore it to how it might have been at the time of their ancestors."

From the mainland, it's a short boat hop to the fifteen-acre island. When you round a corner, you catch the first glimpse of the island boathouse, an enchanting structure afloat in a protected bay. It looks like something out of a fairytale. The original boathouse was falling into the lake and had to be torn down when Don bought the island in 1993. The new one, designed by architect D'Arcy Dunal and built by Bill Stokes of Windycrest Construction, is a more fanciful structure.

Back in the early 1900s, the island was a hub of social activity. The supply boats stopped here and dropped mail for all the surrounding islands. Cottagers would row across to Monyca to pick up their mail and catch up on local gossip. "We tried to preserve some of the history," says Don, "so we kept the old wooden mailboxes from the original boathouse and put them into the back wall of the new building. They still have names penciled on the little doors."

The Victorian whimsy of the cottage is repeated in design elements of the boathouse. Canary yellow board-and-batten is offset by plenty of white trim and fanciful fretwork. Perhaps the most striking feature is the rooftop cupola. From across the lake on a sunny day, it glitters like a sunburst. Bill Stokes wanted to try something different, so he designed the cupola with diamond-shaped windows and a cube of mirrors hanging inside. When the sun heats the windows, the cube moves and creates a glinting effect.

At night, the boathouse is even more spectacular, bathed in golden beams of light. Joe Macdonald, the caretaker, who lives with his wife year-round on the island, sums it up when he says, "There isn't any place quite like Monyca Island. It's magical."

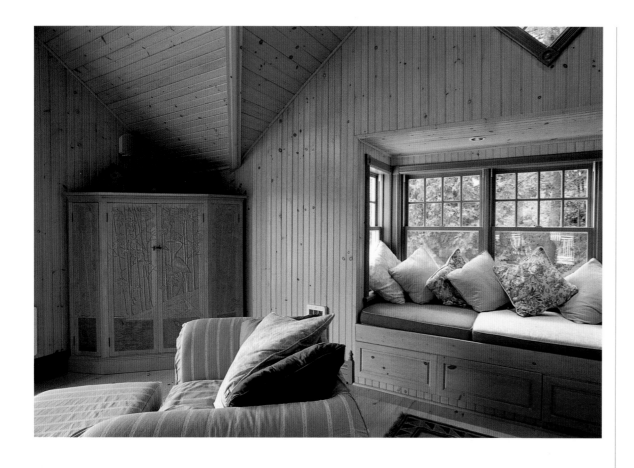

A wooden corner cabinet houses a television and audio equipment. The handcarved doors feature scenes of Muskoka wildlife.

Decorator Scott MacDonald chose historical colors for the interior, warm tones of coral, yellow and green. Friends handpainted the table in the same colors during a weekend visit.

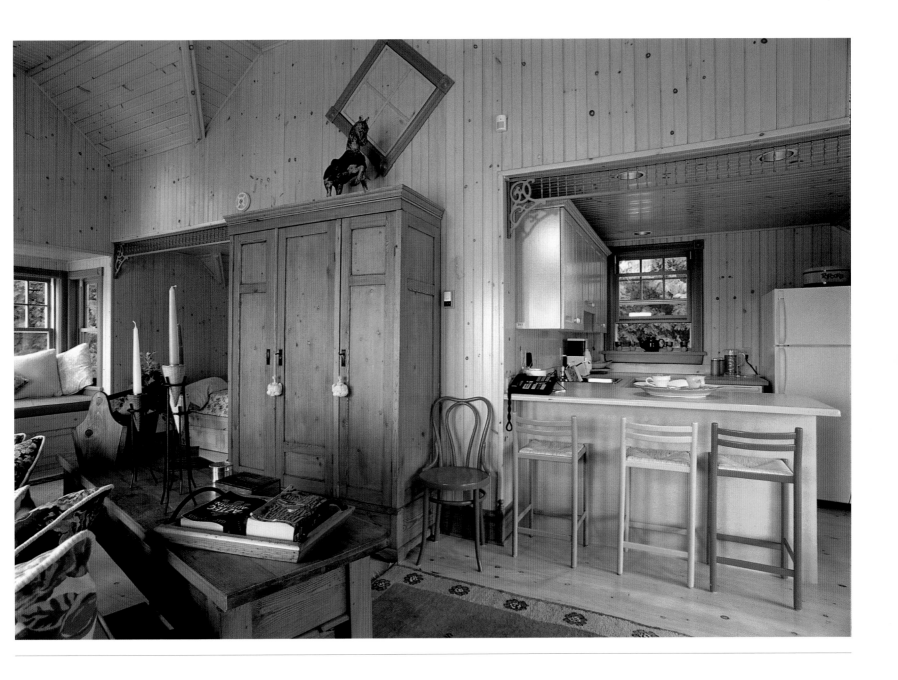

Don Jackson planned the boathouse as a gathering place for his teenage daughters. Instead of a separate bedroom, there's a daybed for napping. The quilt-covered bed is tucked in an alcove with its own window overlooking pine trees and water. Tongue-and-groove pine wallboards were washed with sea green stain followed by three coats of satin finish Varathane. Like the bed nook, the kitchen tucks into an alcove. Matching fretwork unifies the two spaces.

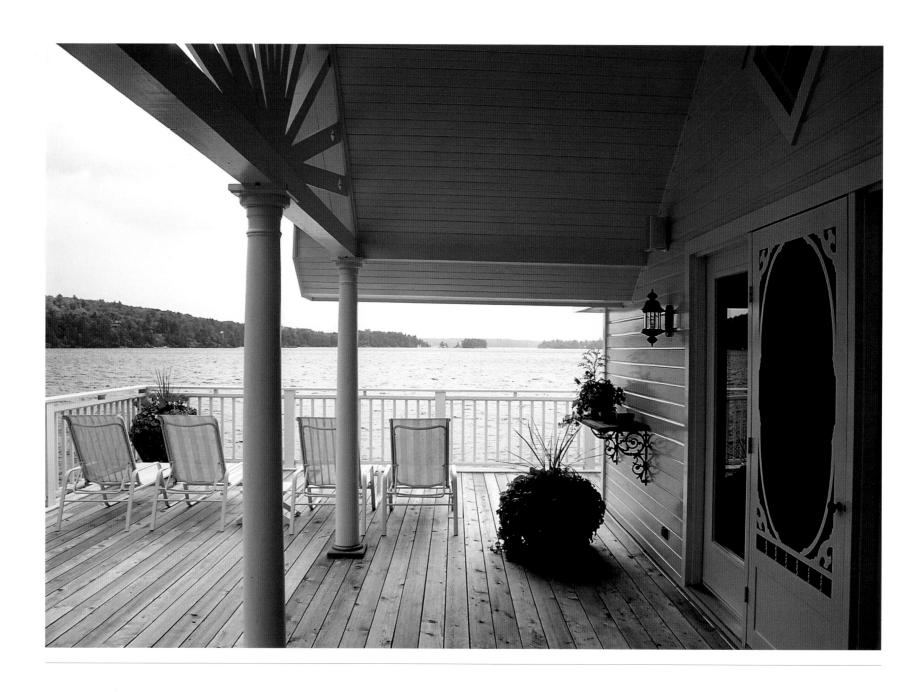

The outside deck offers sun, shade and a long lake view.

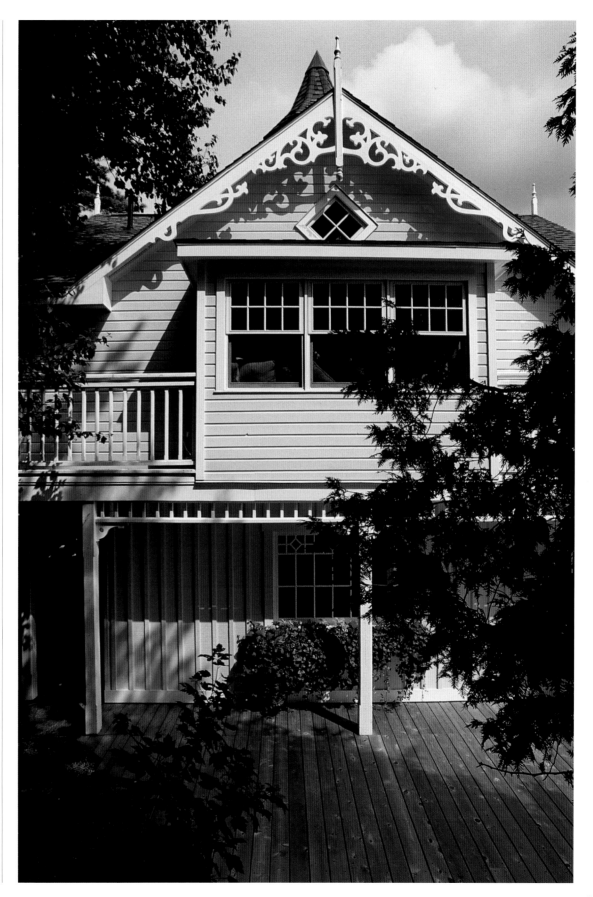

A side view of the
Monyca Island boathouse
shows the living room's
window alcove.

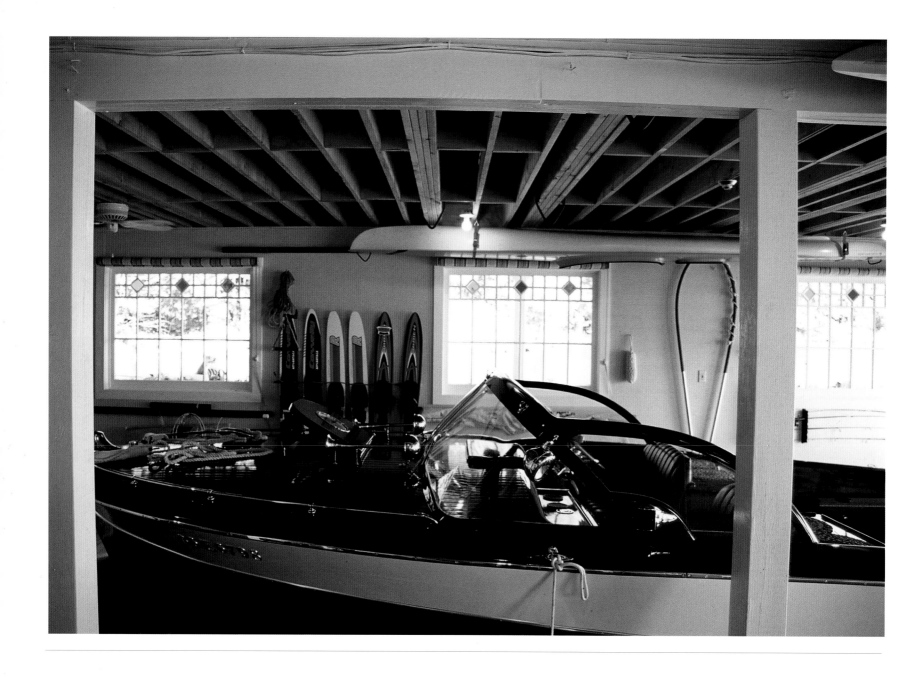

Diamonds of brightly colored glass are copied from the vintage window design in the main cottage. The mainland boathouse, which stores both boats and cars, also has glass diamonds in the windows in these same primary colors.

A trio of crayon-colored chairs looks out on a tiny perfect island.
Less poetic is its name — Garbage Island — bestowed when people used to dump their garbage on it.

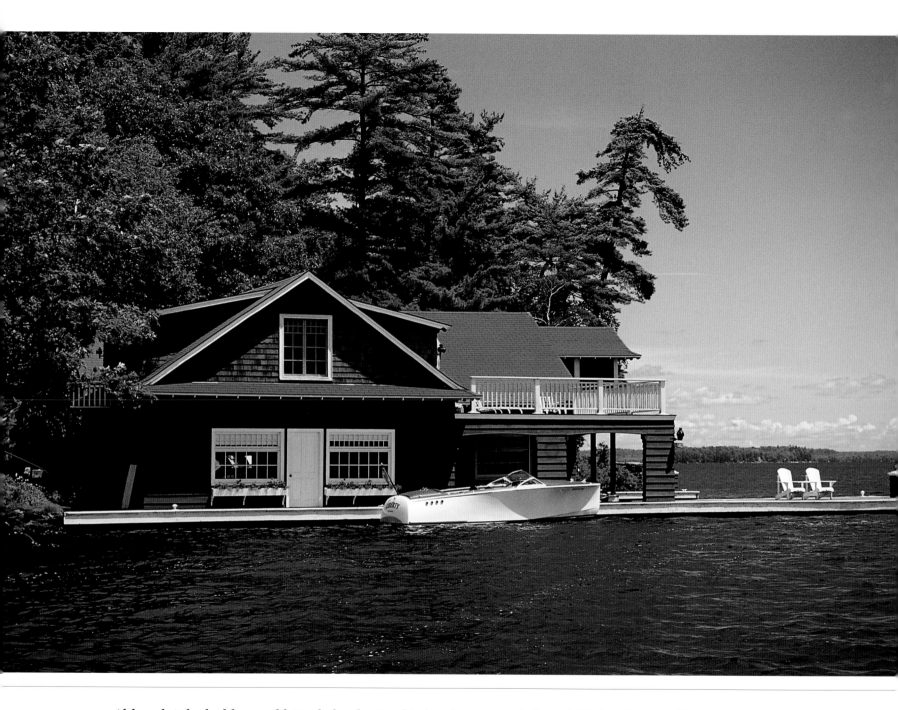

Although it looks like an old Muskoka classic, this boathouse was built in 1992 by Grant Williamson. The architectural details — shed dormers, multipaned windows and exposed rafters — were popular boathouse features at the turn of the century, as was the hillside elevator that hoists supplies from the boathouse up the hill to the main cottage.

BRIGADOON ISLAND

LAKE MUSKOKA

When the R.M.S. *Segwun* and the *Wanda III*, Muskoka's lovely old steam cruisers, set off from Gravenhurst on a sunset jaunt, they head north up Lake Muskoka until they reach Brigadoon Island. Here they turn, just in time to watch the sun dropping down between Grandview and Cinderwood Islands. Then, as twilight descends, they head back to home port, bidding farewell to Brigadoon.

"Sitting on the screened portico of the boathouse and watching the steamboats cruise by was a great delight," says the former owner of this enchanting isle. "The boathouse is perfectly sited to watch the lake activity." Recently, Brigadoon changed hands. The new owners bought the island with its eight-bedroom wood-lined cottage and spacious guesthouse mainly because of the boathouse. They needed a slip long enough to berth their newly acquired thirty-six-foot Ditchburn.

Brigadoon was first purchased from the Crown in 1881. Thereafter many owners came and went. In the early days islands changed hands frequently: as one cottager observed, "Muskoka islands were like penny candy back then — you could buy two or three of them at a time." The original Brigadoon boathouse had been built at the turn of the century by a Pittsburgh architect. In 1960, it burned down and the same architectural firm returned to rebuild it. This time, a smaller, more modest building took its place.

Then in 1992 the owner needed a larger boathouse for his collection of antique boats. He tore down the 1960s boathouse and hired Grant Williamson of Elmo Starr Construction, a builder known for his talent at replicating the old Muskoka style. Without any existing photographs of the original boathouse, they used a neighbor's Beaumaris boathouse built in the same era by the same architect as a guide. They relied on the existing cribs to position and size the building. Some modifications were made, such as leaving an open boat port instead of closing it all in. And the handsome screen portico was included in the new blueprint. This way the entire place can be jacked up when the cribs need replacing. It also prevents rotting where the wood siding meets the wooden deck.

The upper level is larger than it appears from the water. There's one vast L-shaped room with a sitting area, kitchen, pantry, washroom and bedroom with a master bed as well as single iron beds tucked into nooks and draped in mosquito netting. The wall planking of the post-and-beam interior is laid in a V-pattern in order to appear more nautical. The painted wooden floor is dark green and all the walls are white, with tiny lights beaming up to the exposed rafters of the vaulted ceiling. It's a comforting place to be, especially as the sun goes down and the haunting toot of the steam whistle means the *Segwun* will soon sail by.

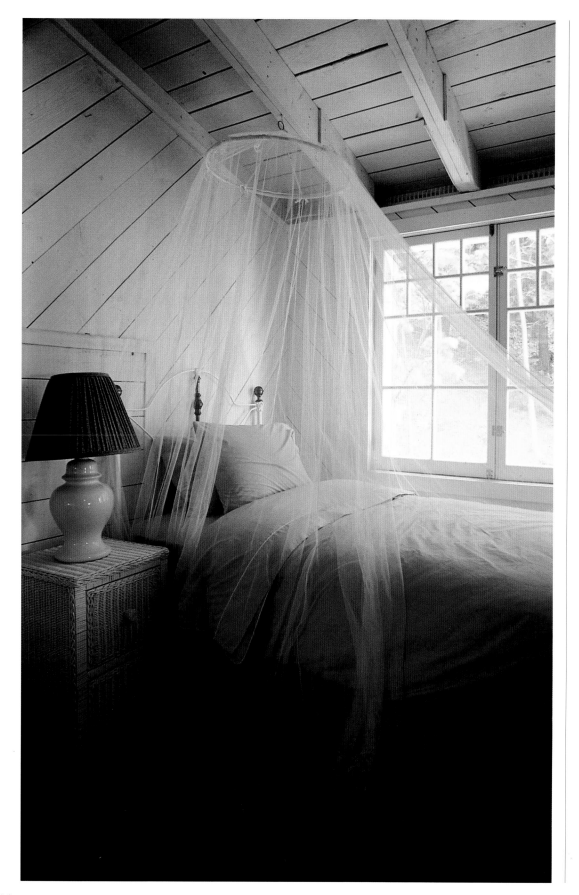

Old wicker freshened with white paint adds to the summery appeal.

A dreamy canopy of mosquito netting on the beds is "more for effect." Lake breezes blow in from all directions, keeping the rooms bug-free.

Exposed trusses and rafters add interest to the generous interior.

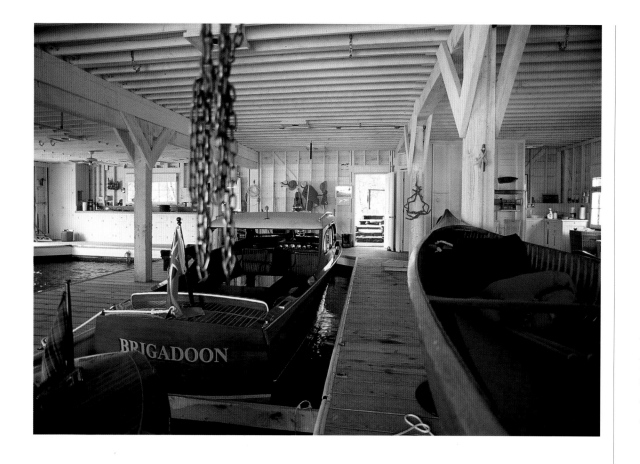

Extra-long slips provide room for antique boats. The *Brigadoon*, a 1941 MacCraft, holds pride of place. Built as an offshore patrol boat on Lake Huron, she has been passed on to each successive owner of the island.

A tree grows through it.

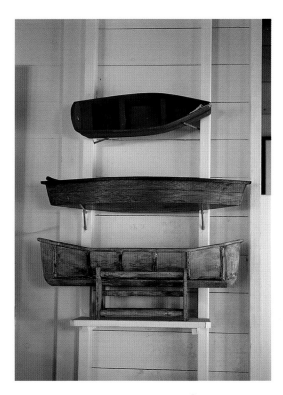

A more primitive form
of the classic wooden boat,
miniature style.

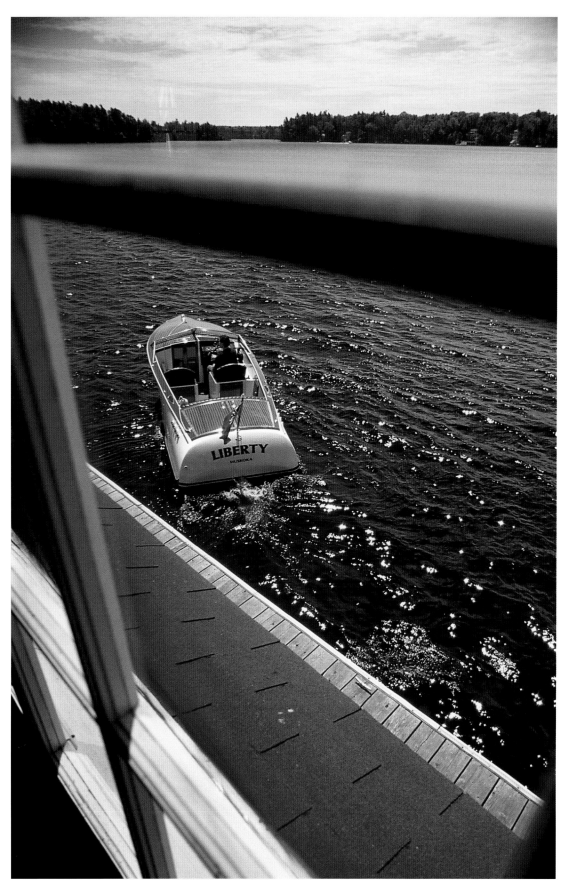

The *Liberty* motors away from
Brigadoon toward the north
end of Lake Muskoka.

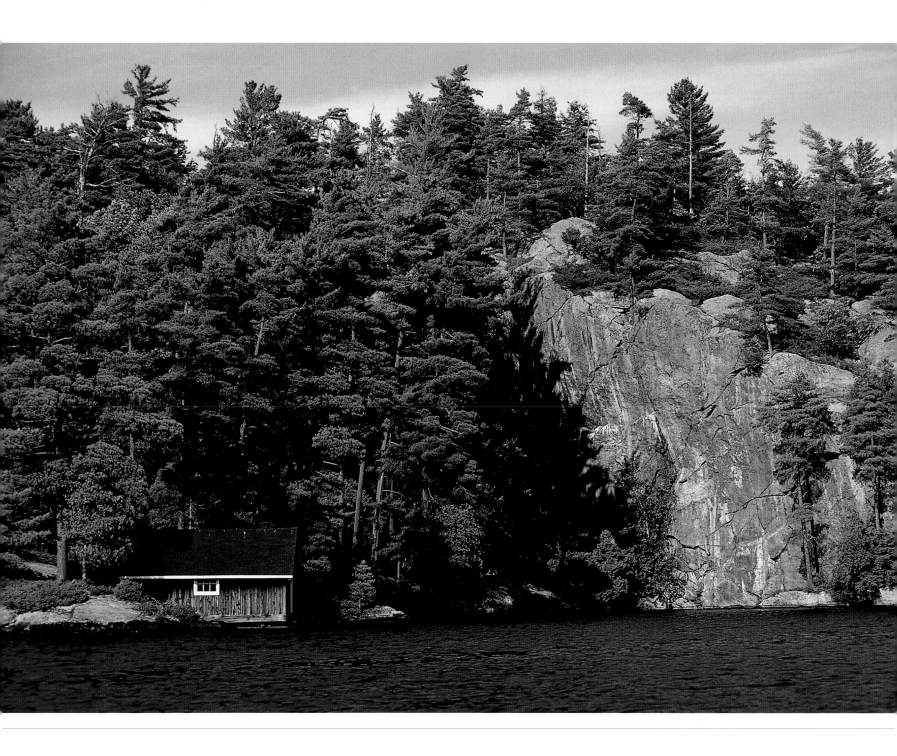

The cliff that gave the island its name provides a dramatic backdrop
to the cluster of boathouses and sheds at the water's edge.

CLIFF ISLAND

LAKE JOSEPH

There's a certain area about midway up Lake Joseph where it's easy to believe that you've stepped back in time. Many of the boathouses look just as they did in the Micklethwaite photographs taken at the turn of the century. These classic wooden structures were erected to shelter boats and house staff in the days when households were run by servants. Lacking architectural pretension, they offer a decided contrast to the immense new designer boathouses sprouting elsewhere on the lakes.

Cliff Island is one place with a clutch of these vintage boathouses. They huddle, all dark brown and somewhat decrepit, in a bay next to the famous cliff. The sixty-four-acre island is the largest private island in Muskoka, owned by the same family since the late 1800s and never divided. Jerry Hamlin shares Cliff Island with his sister, Lucile, and an uncle, George Forman Jr. It was Jerry's great-grandfather who came to Muskoka from Buffalo before the turn of the century. "He cruised all over the lakes in a houseboat," says Jerry. "He had the pick of the lakes then, and this is what he chose."

The main cottage, a rambling Adirondack-style place hidden in the woods, was designed by Buffalo architect Edward Green and completed by 1898. The launch boathouse was built then too, with a boat chauffeur's room in the upper level. Today, there is no boat chauffeur and the upstairs room is boarded up, its back staircase rotting away. Jerry says wryly,

"Our boathouse is developing character — it's sinking and rising in different places."

At the water level, the boathouse is like a musty old museum with antique vessels piled in corners and heaped on rafters. There's a dugout canoe, rowing skiffs and Jerry's California Drag Boat, a 1965 Rayson Craft that was once the fastest boat on the lake. Propped in one corner is an old Peterborough Aqua Board that they used as kids. Nothing, it seems, is ever thrown away at Cliff Island.

The boathouse was built originally to house the Forman's steam yacht, the *Iagara* (it was to be named Niagara but the letter "N" never arrived). Used by the family for many years, it ultimately met an unfortunate demise as a hotdog stand named "Steamers" on Highway 69. All that remains now at Cliff Island is the *Iagara*'s propeller, which hangs over the boathouse door, and her steering wheel, now in Jerry's 1890 steamboat, the *Wendingo* — which is, he says, "the oldest working boat on the lakes."

In the 1920s, a canoe house was put up in the bay alongside the main boathouse. Tucked in the lee of the prevailing west wind, it was used to store boats in winter. In summer, the woodsy room with a stuffed deer head looming over the brick fireplace became the main hangout for the whole family. "This was the swim dock, the fishing dock, the makeout dock. Everything happened here," says Jerry. "As a matter of fact, of all the places on the island, it's still my favorite place to hang out."

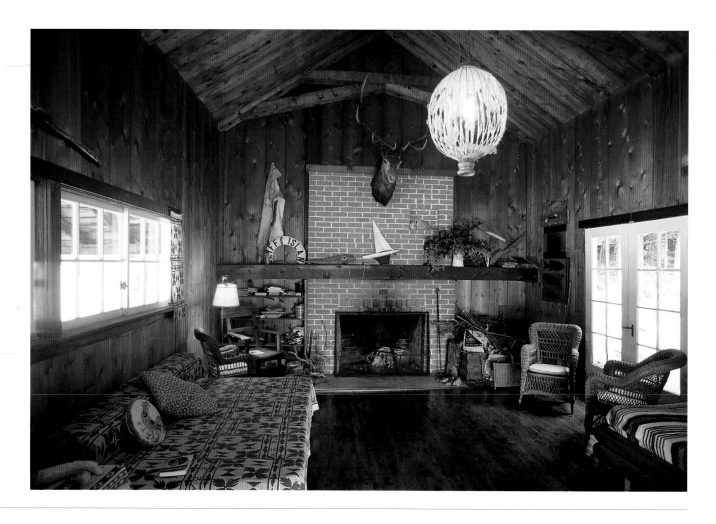

The interior of the old canoe house is a favorite place to relax on summer afternoons. Built in the 1920s in a protected cove, it has developed character over the years. Porcupines have chewed away railings and doors — as Jerry says, "It's a well-chewed establishment."

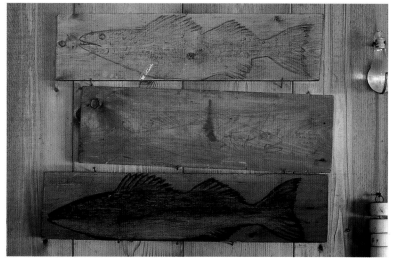

When the Cliff Islanders were children in the '40s and '50s, fishing was a prime activity. Whenever they caught a large fish, they would paint an outline of it on a wooden board. These were hung with pride on the walls of the canoe house. They're all still there.

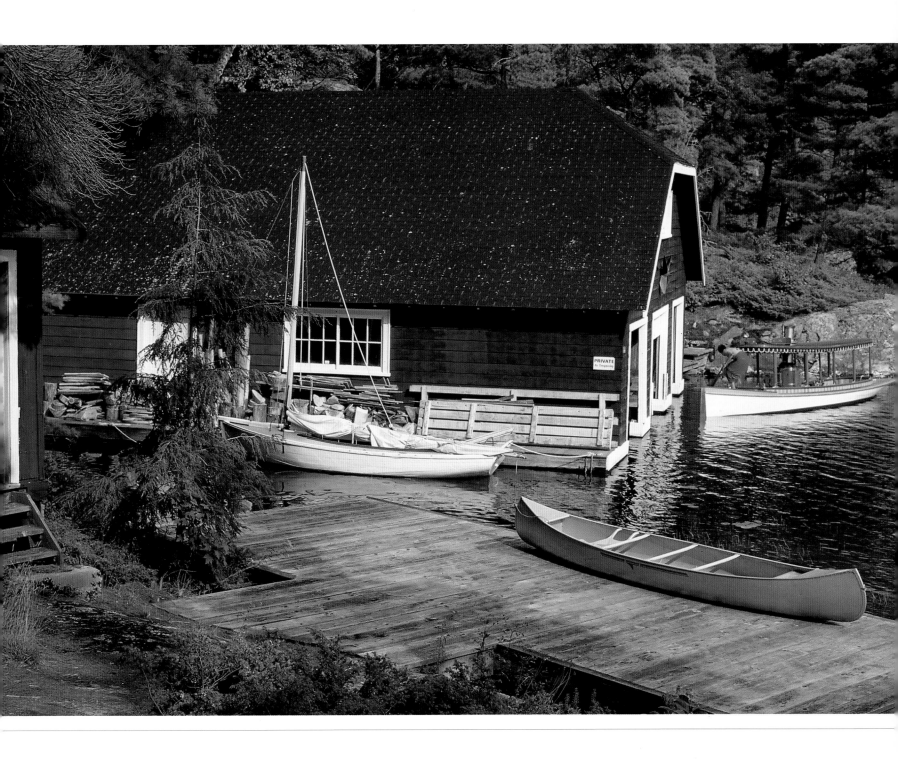

Wendingo, being paddled into the boathouse. According to Jerry Hamlin, who admits to being "a steam nut,"
she's the oldest working steamboat on the lakes.

BLUEBERRY HILL

L A K E R O S S E A U

When Carol and Michael Nedham bought the steeply sloped lot on Lake Rosseau, it was covered in blueberries. Then the blasting began. In order to build the cottage, they had to blast away some of the rock. Today the moss green cottage is tucked snugly into the hillside, a long, narrow building with a projecting prow. Flagstone steps lead to the water and a boathouse. Now that the blasting dust has settled, the blueberries are taking root again, creeping across the rocky landscape — hence the name of this handsome summer property. "I was so pleased to see the blueberries," says Carol, "that now I always serve blueberry dessert when we have guests."

Both the cottage and boathouse were designed by Jamie Wright, a Toronto architect who first spent some time boating on the lakes, collecting ideas. "I discovered," he says, "that most boathouses built from the 1950s to the 1970s looked like suburban houses. And many of the new ones, I thought were too ornate." For the Nedhams, he designed an unassuming building with exposed structural elements and woodworking details more in keeping with Muskoka boathouse architecture of the 1920s. Great swooping eaves extend four feet over the surrounding decking to provide shade on all sides and effectively lower the scale of the building. The angular support brackets beneath the eaves are aesthetically pleasing and, according to the Nedhams, don't seem to appeal to nesting swallows — a decided bonus.

An outside staircase leads to the upper level, which has two bedrooms, a sitting area, a small kitchen and bathroom. High ceilings soar over the sitting area, a great expanse of window lets in plenty of light, and glass doors lead to a French balcony with space for two chairs.

Bill Stokes of Windycrest Construction built the boathouse, taking Jamie Wright's architectural concepts and "fancying things up a bit." "We like to create an older look," says Bill, "with details like chamfered posts and fish-scale shingles." He always leaves a trademark design element too — like the custom wooden finials in the dormer peaks. But it was his practical ideas that the Nedhams appreciated most — such as the inset back door, which created a little entrance nook at the top of the staircase. He suggested the removable section of railing opposite the back door; the railing lifts right out to allow furniture such as the large blue armoire to be hauled inside. And he built generous shelves over every window inside to provide extra display space.

The resulting boathouse was the product of a successful collaboration. "We were lucky," says Carol, "to have both a good architect and a good builder."

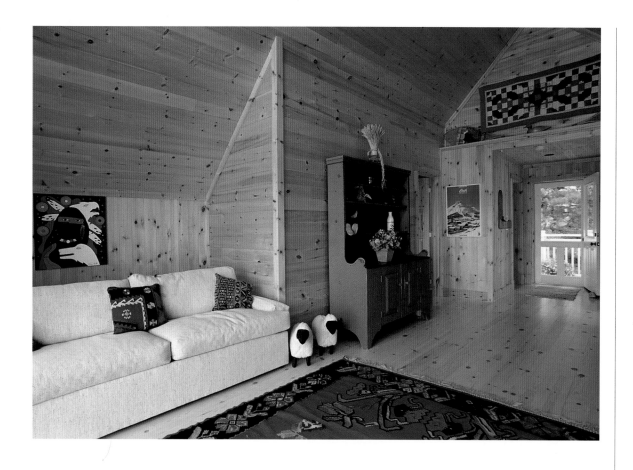

Finishing the interior in tongue-and-groove pine was going to be Michael Nedham's summer project, but time ran out after he did the ceiling. Now cozy and complete, the room has French doors that open onto a balcony.

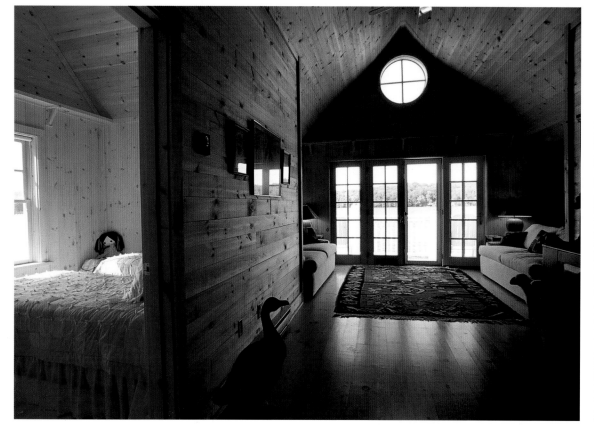

OVERLEAF:
The underside of the swooping eaves is ribbed like a cedar-strip canoe. On one side the deck extends to accommodate a circle of primary-colored Muskoka chairs.

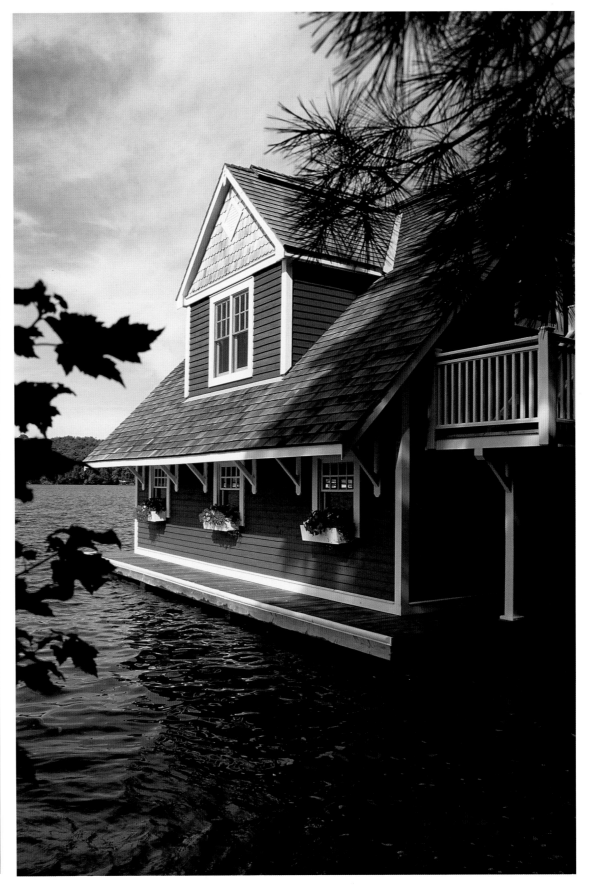

The boathouse, with its deeply sloped roof and wide eaves, was designed by Toronto architect Jamie Wright. "The idea is to bring the scale of the building down," he explains, "and to have it fit with boathouse architecture of the past." The exterior is clad in prefinished wood siding.

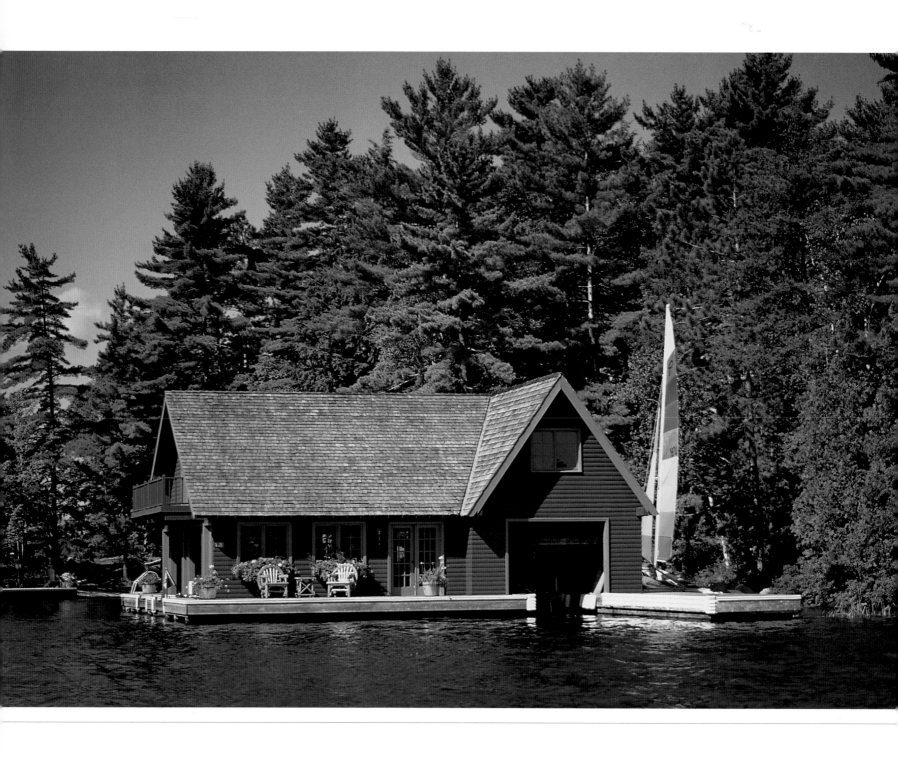

One of two boathouses on Christmas Island. This one was built in 1988.
AT RIGHT: The restored canoe house on Fawn Island.

12

CHRISTMAS ISLAND

LAKE JOSEPH

When old established islands get new owners, the neighbors usually wonder what changes will take place. Will the character of the heritage cottages be destroyed? In the case of Christmas Island and Fawn Island, both on Lake Joseph, the worries have subsided. New owners, a couple with family roots in Muskoka, are transforming the islands into classic summer retreats with all of the old Muskoka character intact.

Both admit they keep gravitating to the tiny canoe house that perches on the shore of Fawn Island. "It's so romantic," says the owner of her hideaway. "It's a real water house. The bed faces east and the sunrise is literally blinding. Last summer when I was nursing our baby, it was just a great place to be. Very grounding and calming — for me and for the baby too."

When they bought Fawn, they wanted to restore the canoe house, which had been built by the original owners of the island in 1894. It had been lived in then but in later years was used merely to store canoes and other boating paraphernalia. The upper level, accessed by a back staircase, had a tiny airless bedroom with small windows. Jamie Blair, a period designer and builder, worked with the owners on the restoration using the footprint of the original. It was taken apart and reassembled joist by joist, piece by piece. "Basically," says Jamie, "we took an old utilitarian structure and beautified it."

To accomplish this, the exterior was shingled in cedar with flared edges at the base to give it the appearance of melting into the decking. New windows and doors on all sides offer spectacular views of the ever-changing lake waters. Stone walls were shored up and a flagstone patio fans out around the base. The upper level is a light-filled bedroom and downstairs there's a sitting room that the owner, a photographic artist, plans to use as her studio. In winter the canoe house still functions as a dryland boathouse when canoes and skiffs are hauled in through the wide doorway.

At Christmas Island the couple are reviving two boathouses. One, a flat-topped utilitarian structure built in the 1940s, has been made more attractive with the addition of French doors at the dock level. The second, a three-slip boathouse, was built for the former island owners in 1988. The half-log siding was chosen to complement the Adirondack-style cottage. In the upper level there's a guest bedroom, bathroom, large exercise and games room and a his-and-hers office space. At water level, a pair of classic boats occupy two of the slips. There's already a workroom in this area, and the owner plans to make his office here and create a lounge with comfortable armchairs. "After all," he says, "guys just want to hang out in boathouses."

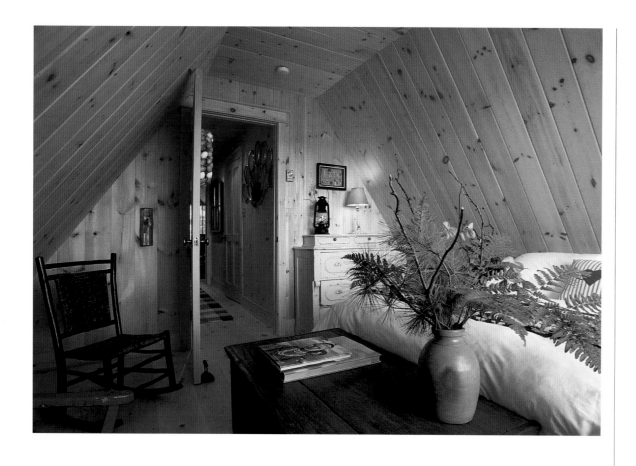

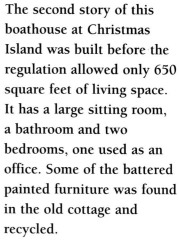

The second story of this boathouse at Christmas Island was built before the regulation allowed only 650 square feet of living space. It has a large sitting room, a bathroom and two bedrooms, one used as an office. Some of the battered painted furniture was found in the old cottage and recycled.

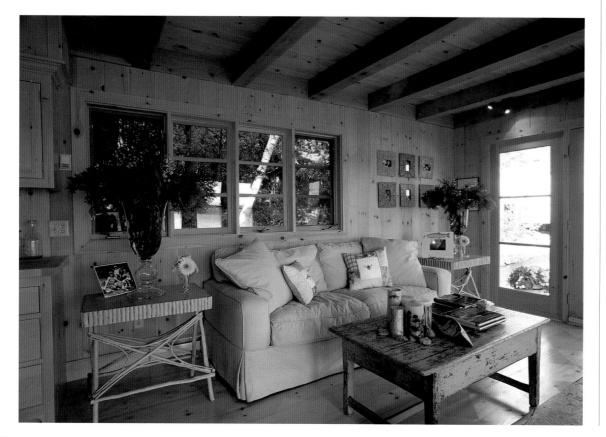

The sitting room on the lower level of the canoe house was once a cluttered storage room. The style of the new windows and glass doors were inspired by a villa in Tuscany.

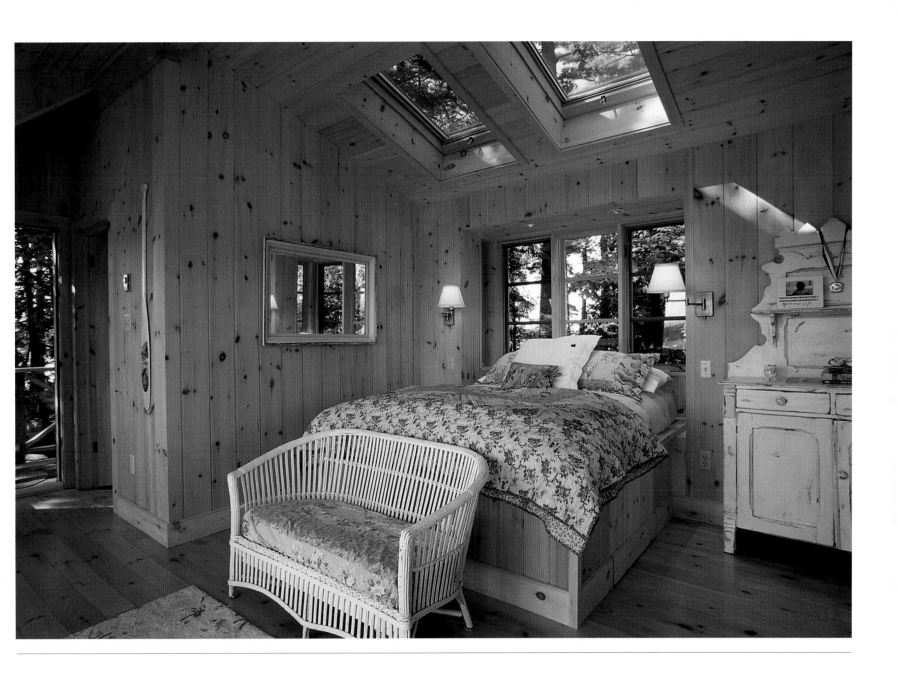

The box bed in the canoe house is built into a windowed alcove.
Beneath it are storage drawers; above, skylights look into the pine trees.

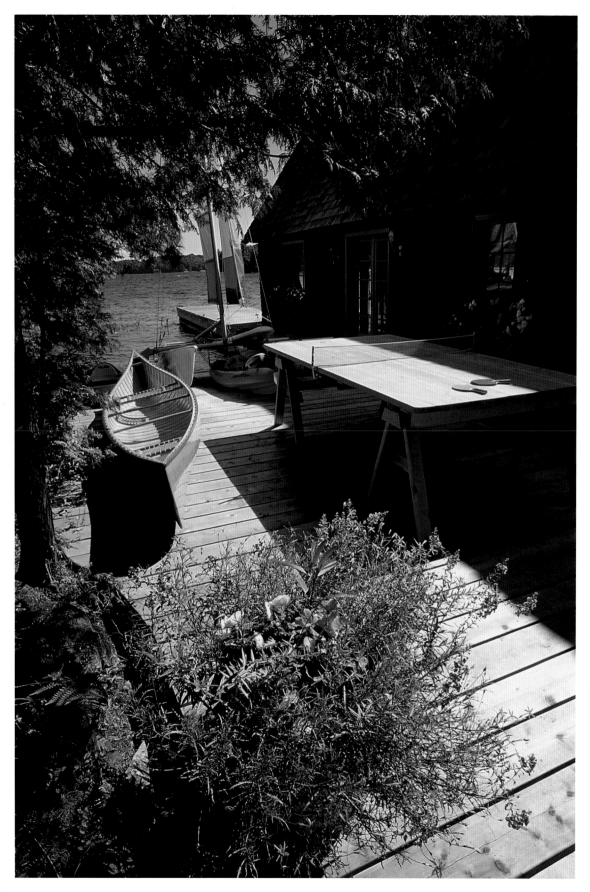

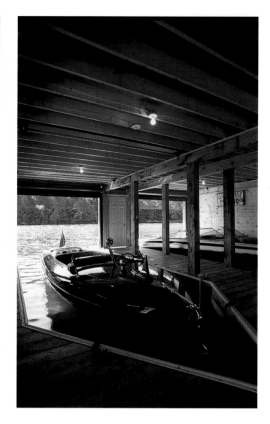

One of two boathouses on Christmas Island, this three-slip one, built in 1988 to house a thirty-six-foot Minett, was recently repainted in sage green with lighter trim. Inside is the *Rascal*, a 1926 Gold Cup Racer, and *Taipan*, a cigar boat with an S-formation cockpit. On the back dock is the family's homemade outdoor ping pong table.

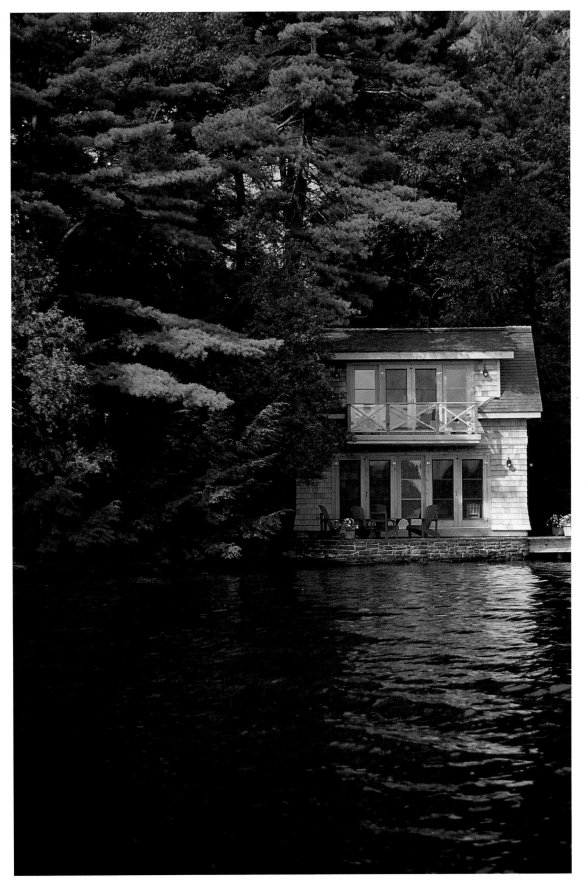

Jamie Blair, a specialist in Muskoka architecture, restored this canoe house tucked in a cove on Fawn Island. The stone patio forms part of the inside floor and fans out from the base outside as well. The upper balcony railings have childproof plexiglass panels.

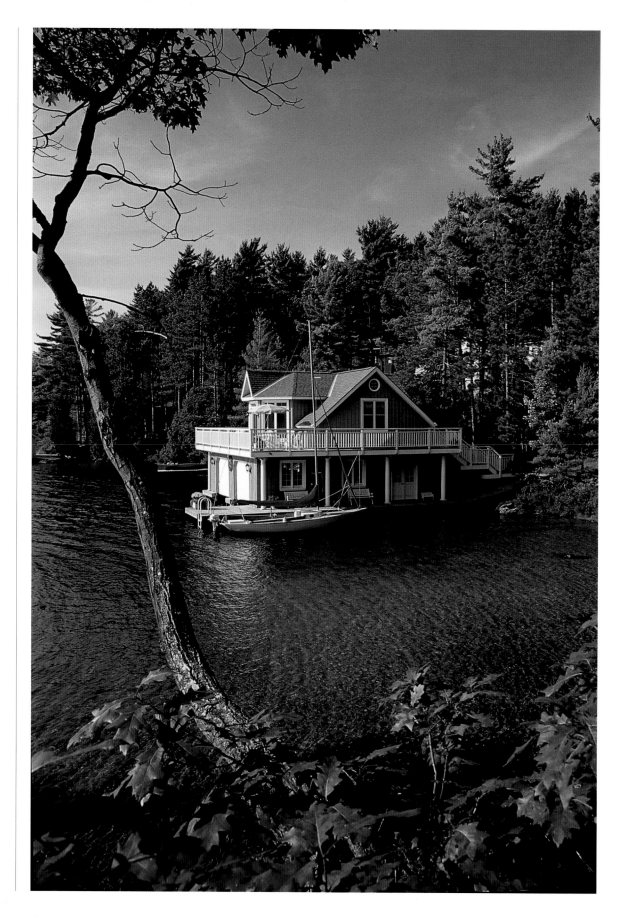

"Experience the true essence of Muskoka," says the brochure for TamLwood, a bed-and-breakfast on Lake Joseph. Most guests arrive by boat to stay in this boathouse.

TAMLWOOD

L A K E J O S E P H

When Ted and Anne Grove built this boathouse in 1998, they planned to use it for family and friends. But Anne had given up a busy career to spend the summer at her cottage and was worried that she would find it lonely — or not have enough to do. A friend suggested that she turn the boathouse into a bed-and-breakfast. "It was a great idea," says Anne. "I have had such fun with it and met so many interesting people. I just hated the idea of the boathouse sitting empty and nobody enjoying it."

The setting is lovely, a pristine lot forested in red and white pines with a natural sandy beach in a protected cove. On one side the land rises in a steep ridge of granite, on the other the boathouse is angled to capture the long view down Lake Joseph. The Groves bought the property in 1991 and kept as many pine trees as possible during cottage construction in 1994. Those that had to be removed were milled on the property and made into the wall and floorboards for the cottage.

The board-and-batten boathouse is stained in a soft putty color with white trim. It has angled rooflines, and four sturdy columns beneath the deck overhang on both sides and wide trim on the multi-paned windows. Ted did a lot of the building himself, choosing elements that would blend with the cottage. The named their summer home TamLwood, an acronym for the family names: Ted, Anne, and their three daughters, Meredith, Lindsay, and Whitney — plus Wood for the woods on the property.

Anne runs the bed-and-breakfast from Monday to Thursday, mid-May to mid-October. On weekends she makes it available for family. It's the only b-and-b on Lake Joseph, and as far as she knows, the only boathouse b-and-b in Muskoka. Many of her guests arrive by boat. During the day they enjoy cruising the three lakes and then at night they return to this comfortable abode.

There are two large bedrooms, a bathroom and a sitting area with a small kitchen. Furnished in country-style décor, with all the cottage comforts, it also has a deck that wraps around three sides. Breakfast is served at the main cottage or at the umbrella table on the sunny deck.

After its first season as a b-and-b, TamLwood has proven a success. "Everyone who stays here has been wonderful," says Anne, who enjoys it as much as the guests. "They all seem to be thrilled that we would share this place with them."

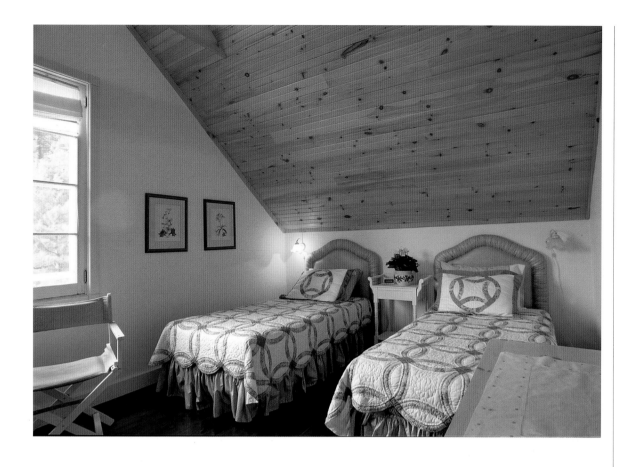

A choice of dreamy bedrooms for guests at this Lake Joseph bed-and-breakfast.

The twenty-one-foot day sailer tied at the dock is the *Fifth Lady.* Ted Grove chose the name because he has a wife and three daughters. The Groves use the boathouse for family on summer weekends and run it as a b-and-b during the week.

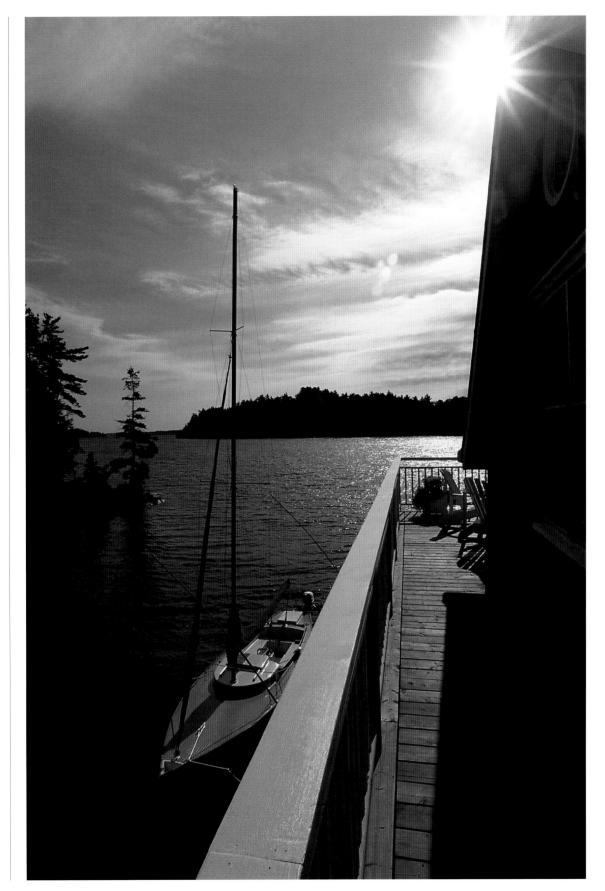

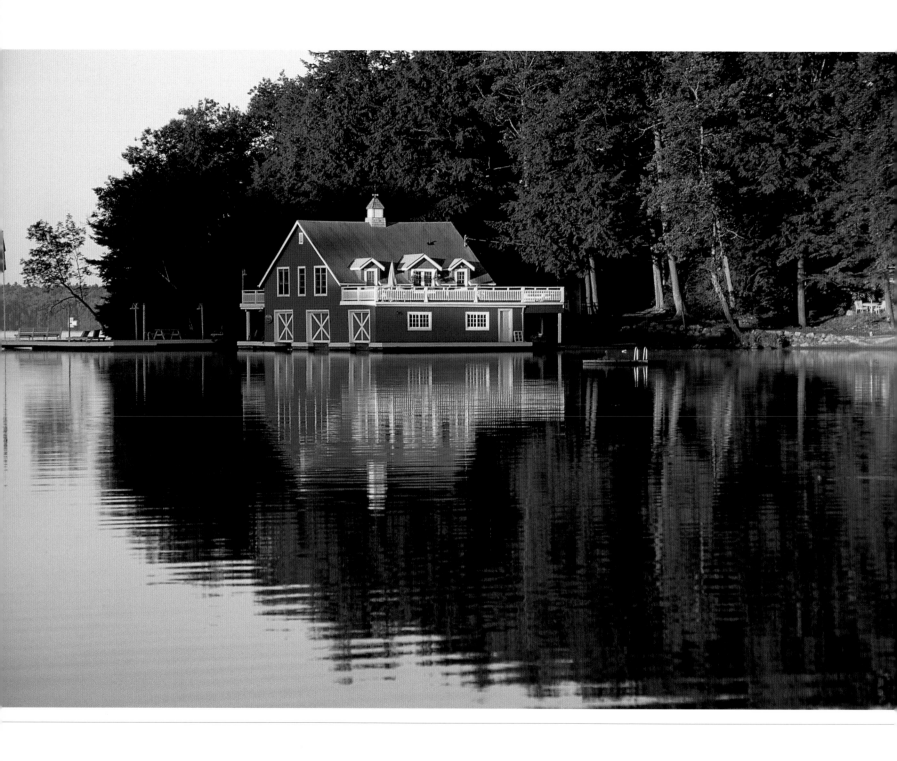

Marmilwood, the boathouse cottage of Jack and Dolena Hurst,
was once used as a convalescent hospital by the Royal Canadian Air Force.

MARMILWOOD

LAKE MUSKOKA

The boat came first. Jack Hurst bought a 1938 Greavette Streamliner and needed a place to store it. Then one thing led to another. He and his wife, Dolena, decided that the boathouse should serve two purposes — storage for the new wooden treasure and living space for them to use as a cottage. The couple wanted to live right on the water, but this turned out to be more difficult than they expected.

They searched the lakes to find that most of the newer boathouses conform to the maximum 650 square feet of living space, which was too small. Older ones that offered more space came with large cottages as well, which the Hursts didn't want. Their search finally ended at Marmilwood, a rambling boathouse on Lake Muskoka.

It was large because it had originally been two separate side-by-side boathouses, part of a summer estate owned by Robert Eaton, a nephew of department-store magnate Timothy Eaton. He named his summer property Marmilwood after his two daughters, Margaret and Mildred. Later, during the Second World War, the entire property (by then owned by the Farwell family of Waterdown, Ontario) was handed over to the Royal Canadian Air Force. It functioned as a convalescent hospital from May to October. In the years from 1942 to 1945, hundreds of servicemen recuperated in this lovely setting.

A headline in the Toronto *Evening Telegram* of Saturday, July 28, 1945, reads: "RCAF Convalescents Bask in Luxuries of Swank Muskoka Estate — Life One Grand Round of Sports and Amusements — And Sleeping." Jack and Dolena framed the clipping and hung it in the boathouse bathroom. They laugh now because, by the time they first saw Marmilwood, it was far from a swank estate.

"At first sight I thought, No, no — this is in terrible shape," admits Dolena. But they could see the potential. The spacious boathouse, built in 1922, was listing on all sides. They jacked it up and added an extra layer of timbers to ensure that the building rises well above the highest water levels. Then began the slow process of renovating the interior to make it a comfortable year-round retreat. The Hursts' plan is to retire here, so a first priority for Dolena, who loves to cook, was a great kitchen.

They removed walls, replaced windows and rearranged the space, turning it from a four-bedroom into a two-bedroom cottage. A tiny third bedroom is Duffer's Den, the sleeping quarters for Duffer, the Hursts' friendly mutt. The old captain's quarters from the RCAF days is now a twin guestroom that opens onto the back deck. And Dolena's new kitchen gleams with state-of-the-art appliances.

Metal hospital beds from the war years are still in use.

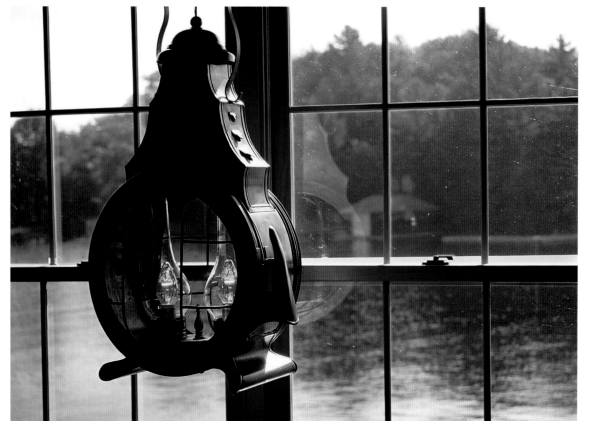

The old marine lantern was electrified and now hangs in the living-room window.

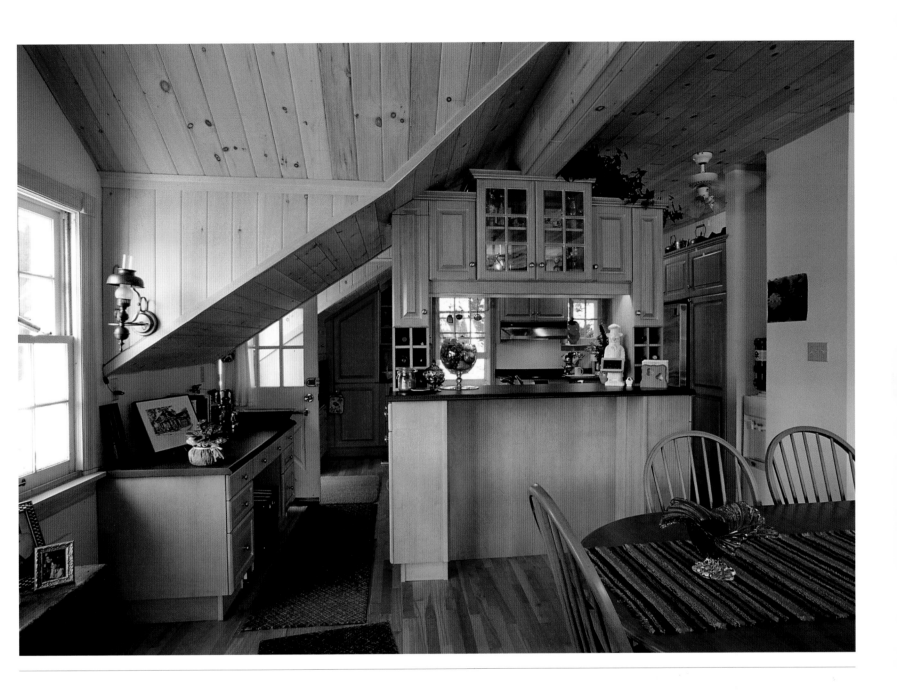

The interior was redesigned to create a large open kitchen.

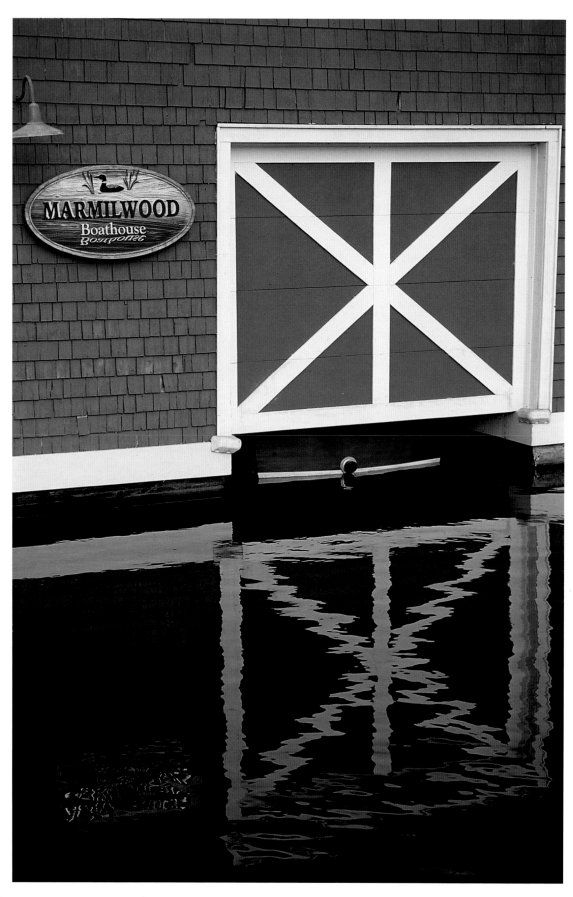

Blue on blue on blue.

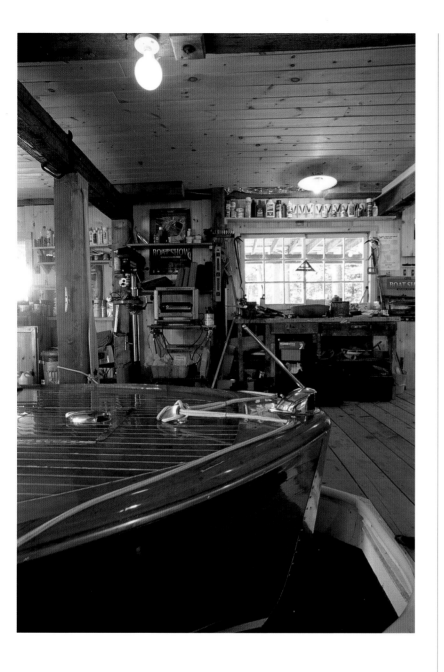

Jack Hurst's 1938 Greavette Streamliner at home.

Traditional Muskoka chairs are stained to preserve the warm color of cedar.

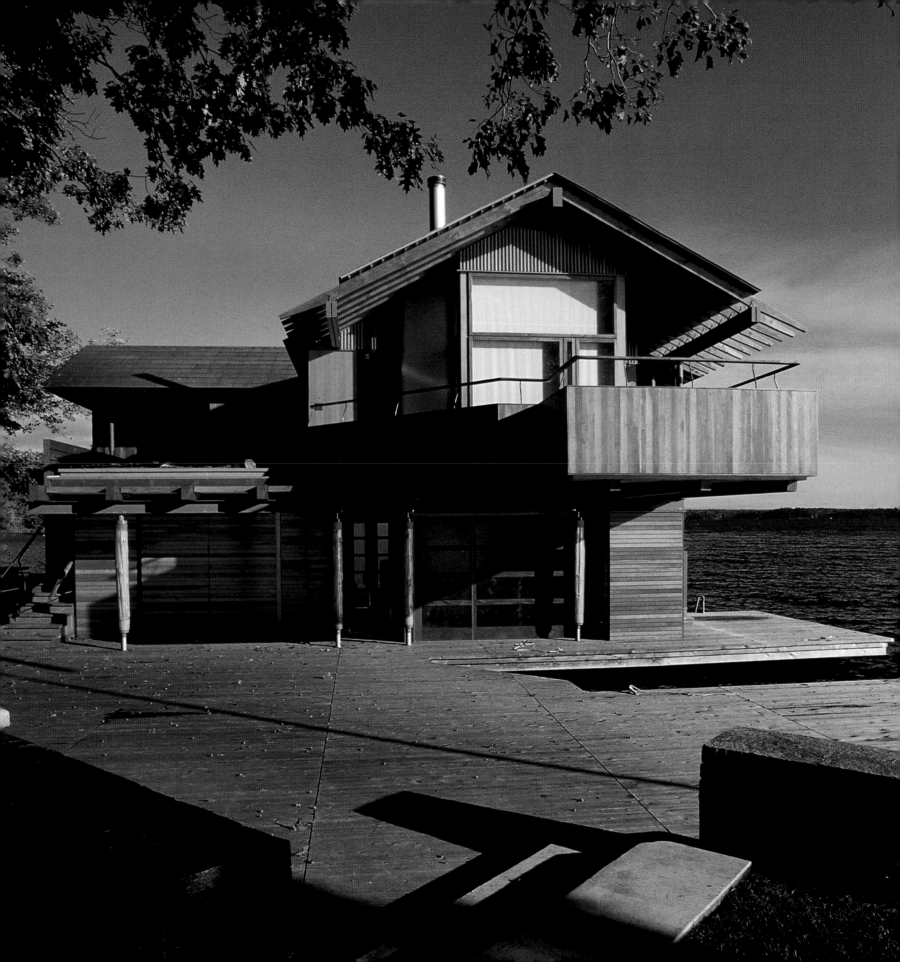

15

POINT WILLIAM

LAKE MUSKOKA

Designing a Muskoka boathouse was a new experience for the award-winning Toronto architect firm of Shim-Sutcliffe. "We'd never done one before," says Howard Sutcliffe, who worked on the project with his partner, Brigitte Shim, over a two-year period. "The challenge came from combining such different spaces — a boat garage and sleeping accommodation." The pair, known for their ability to blend buildings into the landscape, wanted to capture a feeling of Muskoka, of Adirondack lodges, of woods and lake and luxury yachts — all abstractions that are imbedded in the design.

When the boathouse was still on paper, it won a Progressive Architecture Award, the American judges calling it "a sophisticated hut in the Canadian wilderness." It may not be exactly wilderness, this point of land on the southwestern shore of Lake Muskoka, but the building *is* more sophisticated than the average boathouse. Elegant wooden walls and cabinetry lend a rustic sophistication to the interior. There's a pleasing mix of BC fir, mahogany, birch, oak and jatoba, a Brazilian cherry.

"The main idea," Howard continues, "was to create an outer wrapper with those heavy timbers of salvaged Douglas fir. They're actually an extension of the underwater crib system and they form a shell, like the exterior of a boat, that protects the finely crafted interior." The inspired 650 square feet of interior space includes a small vestibule, a main bedsitting room with its own private deck, a compact kitchen

built into the mahogany cabinetry of the hall corridor, and a Japanese-style bath and dressing area with double ceramic sinks, a double shower, a deep tub, and windows that face both woods and water.

At the dock level are two covered slips and one open slip protected by the deck overhang. The boat doors are made of opaque fiberglass that recalls the look of Japanese lanterns when light glows from inside at night. Wooden door panels close off the outdoor bar kitchenette when they're not in use. Two sets of staircases lead to the second story, one to the main entrance flanked by a roof garden, and the other to a rear back deck, a protected nook to hide away and read. The decks, designed to capture the sun and block the wind, meld seamlessly with the interior space.

Drawings of the countless design details fill a thick binder that the architects presented to the owners Gerald and Shanitha Sheff when the project was completed. They both appreciate the exacting workmanship and take great delight in their boathouse, which they use all year round. It has the sensuous quality of a luxury yacht, but with extra comforts such as a big soaking tub, a wood-burning fireplace, and a television that disappears out of sight inside a mahogany cabinet. And everywhere they enjoy a view of water or woods. "I love the intimacy of the space," says Gerald. "It's wonderful in all seasons — even in winter it's the ultimate escape."

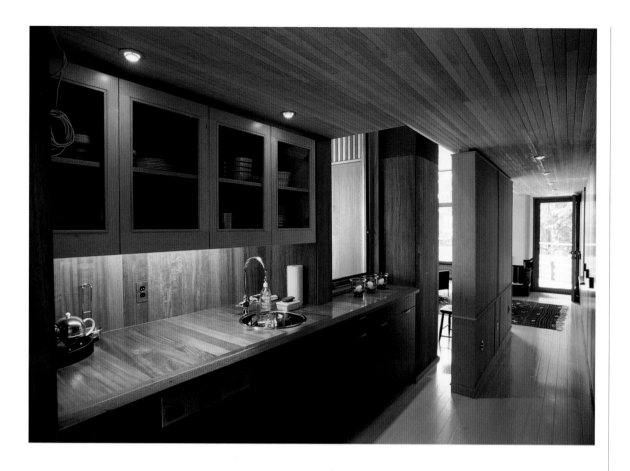

A compact kitchen with custom cabinetry forms part of the corridor. Oak floors painted a mustard yellow provide contrast.

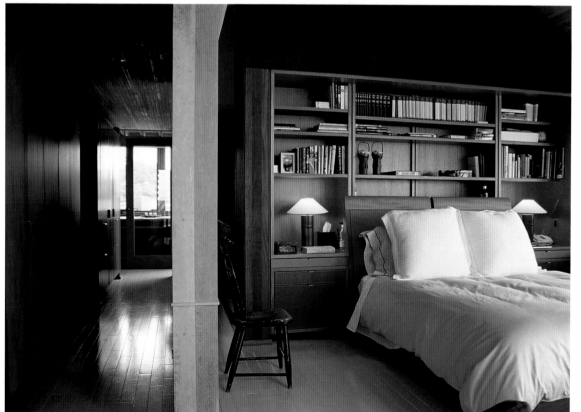

The bedroom furniture fits into the walls, creating a feeling of spaciousness. A curved wooden ceiling keeps the space snug like a yacht interior, and a curved fireplace warms the space in winter.

OVERLEAF:
All the bronzework — custom boat cleats, lights and door pulls — was handcrafted by Takashi Sakamoto from Prince Edward County.

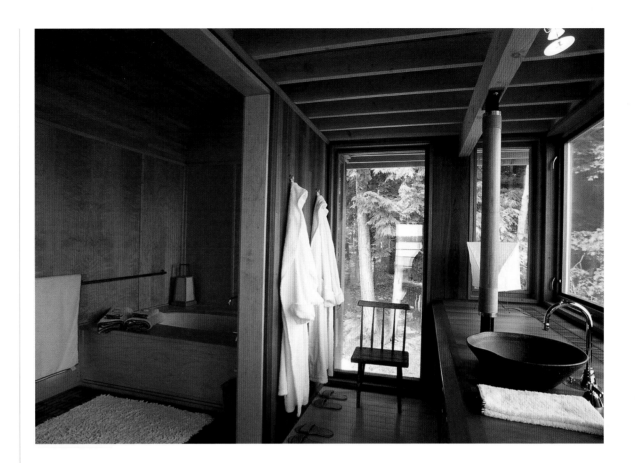

Custom mahogany windows frame two views in the bathing and dressing area.

Ceramic Japanese bowls turned into sink basins are built into the teak countertop.

The bedroom terrace looks down on the dock, enclosed by a low stone wall. Beyond it, a sweep of granite shoreline.

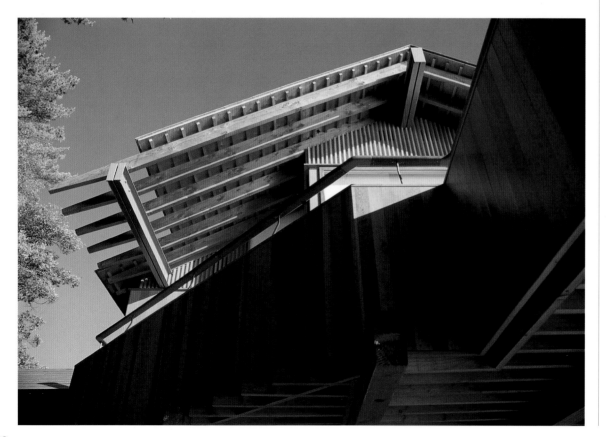

The Toronto architectural firm of Shim-Sutcliffe designed the boathouse for Gerald and Shanitha Sheff. They used a variety of woods, including reclaimed Douglas fir timbers for the boathouse exterior. Exposed wooden joists allow sunlight to filter through to the deck below.

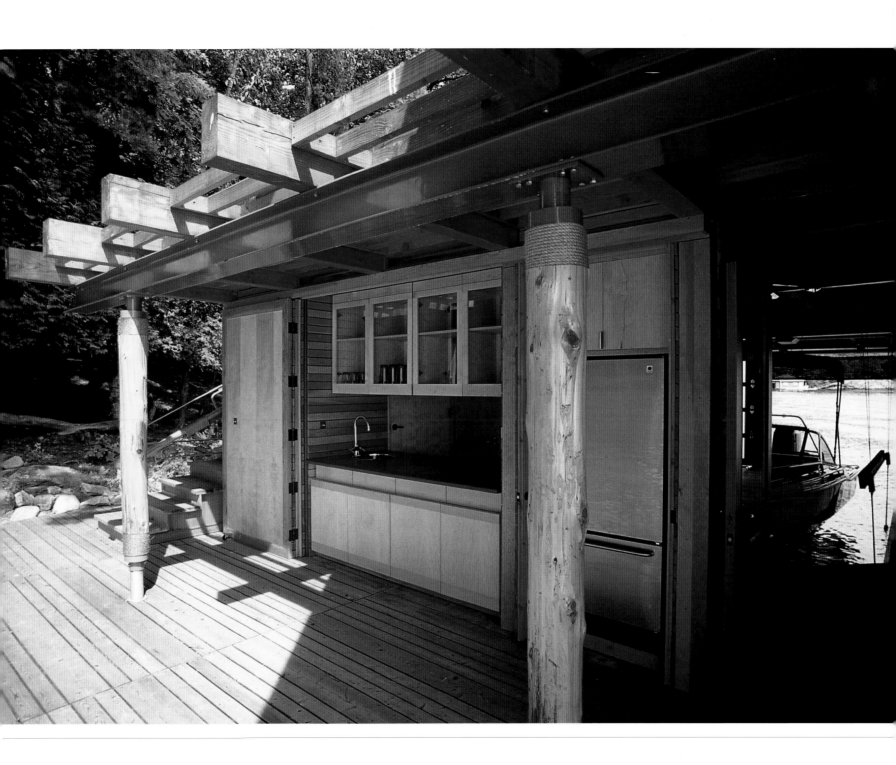

At dock level, the bar area can be accessed from inside the boathouse as well.
Doors fold across to close it off when not in use.

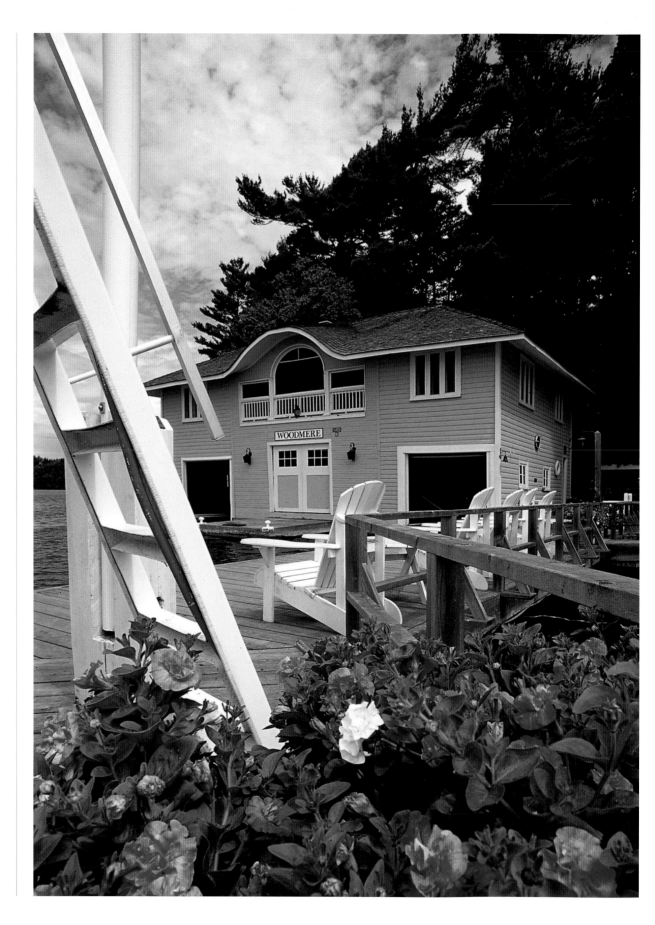

Every year in May, barges full of annuals are brought to Woodmere Island for planting.

WOODMERE

LAKE ROSSEAU

It's something of a miracle that the old boathouse on Woodmere Island is still standing. Two devastating fires, one in 1939 and then another in 1998, destroyed several buildings on this seven-acre island — but somehow the boathouse, built in 1898, survived both times. As a result, it's a favorite hideaway for the island residents. Understandably, they're nervous about fires and nobody dares to light the hearth in the boathouse sitting room.

"We're very careful," says owner Pat Dalton, "especially in this boathouse, which is the oldest building on the island." The middle section of the wood-clad structure was the original dry-slip boathouse for storing rowboats and canoes and is now used as storage space. In the 1920s, the boathouse was expanded, with two slips added on either side and living quarters above. The owners at that time were Lady Annie and Sir Thomas White; he was a cabinet minister in the government of Prime Minister Robert Laird Borden. The Whites sold the island in 1933 to the Hausermann family from Cleveland, Ohio, who owned it for fifty years before selling to Peter and Pat Dalton in 1983.

"This is our family gathering place," says Pat, who spends most of the summer on the island. "We have three families living here with six grandchildren and six dogs — it's the perfect island because we can all have our own space and privacy." For children, Woodmere Island is like a fantasy playground, with pine-needle paths, a stone wishing well and waterfall, a totem pole, sleeping cabins right out of Snow White and the Seven Dwarfs, and a playhouse fashioned from an old chicken coop.

Everything on the island is built to blend into the environment or to look as if it's always been there. Such is the case with the second boathouse, built in 1993 by Port Carling builder Wayne Dempsey. This two-slip boathouse is simple but elegant with decorative wrought-iron accents made by Wayne Church, a local artisan. It also houses a pair of exceptional boats. One is the *Tango,* a 1927 Ditchburn that Pat bought for Peter's sixty-fifth birthday. The other is the *Cameo,* originally a "tender" for the *Parthenia,* a cruise-ship-sized yacht belonging to the F. W. Woolworth family in New York. The tender, a twenty-foot coupe, ferried the Woolworth clan from the yacht to the New York harbor. In 1968 she came to Muskoka, where Pat Dalton first spotted her up on wooden blocks in a parking lot at Port Sandfield. Today she is well used for family outings.

With an island full of cabins and cottages to accommodate all the family members, the vintage boathouse, with its three bedrooms, kitchen, sitting room, bathroom and screened verandah, is used primarily for guests. "And for napping," adds Pat. "When people go missing we usually find them asleep in the boathouse."

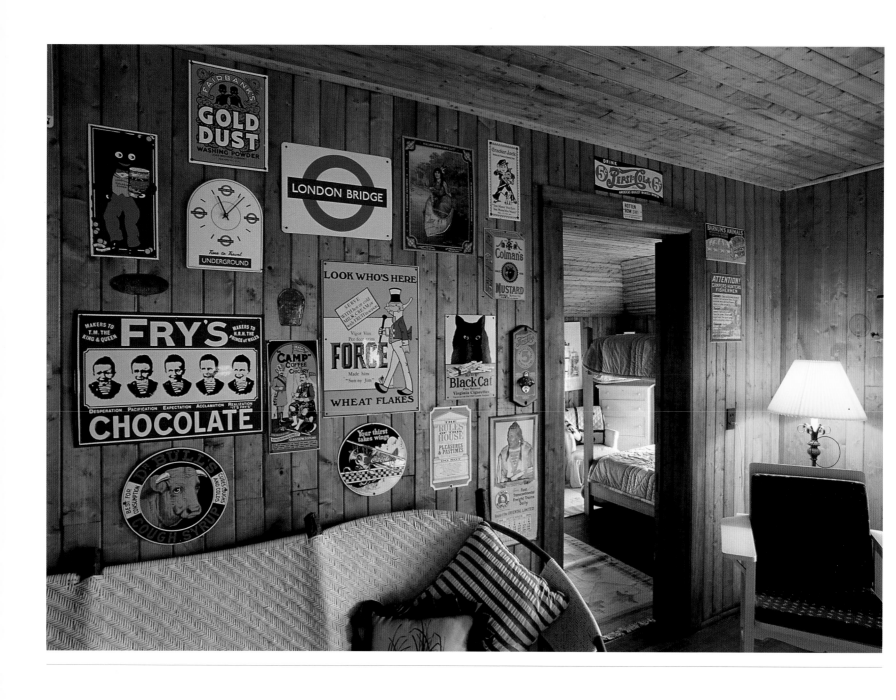

Peter and Pat Dalton collect old tin advertising signs.
The basswood walls have darkened since the boathouse was built in 1898.

The wood-lined bedrooms all have porcelain sinks typical of the period in which the boathouse was constructed.

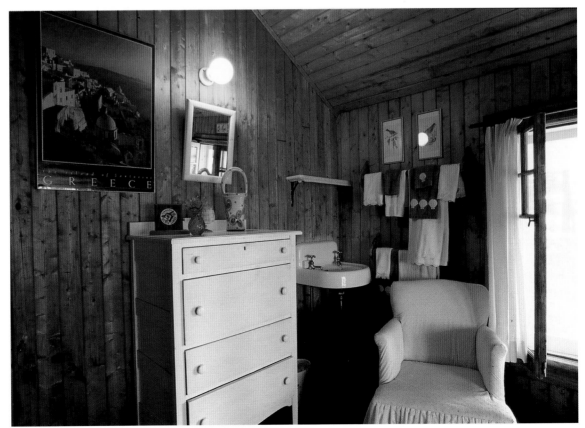

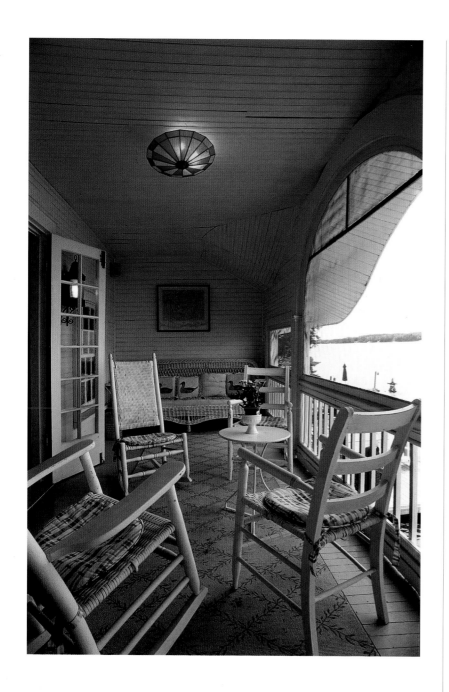

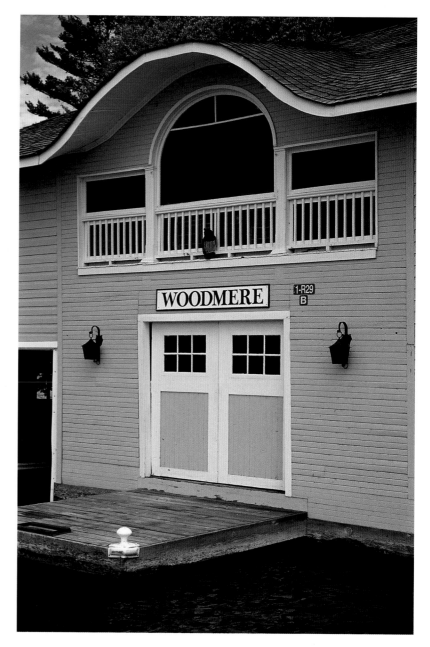

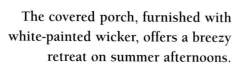

The covered porch, furnished with white-painted wicker, offers a breezy retreat on summer afternoons.

The distinctive curved roof of the boathouse, the oldest building on this private seven-acre island. Beneath the enclosed porch are double doors that open to the dry-slip area, now used for storage.

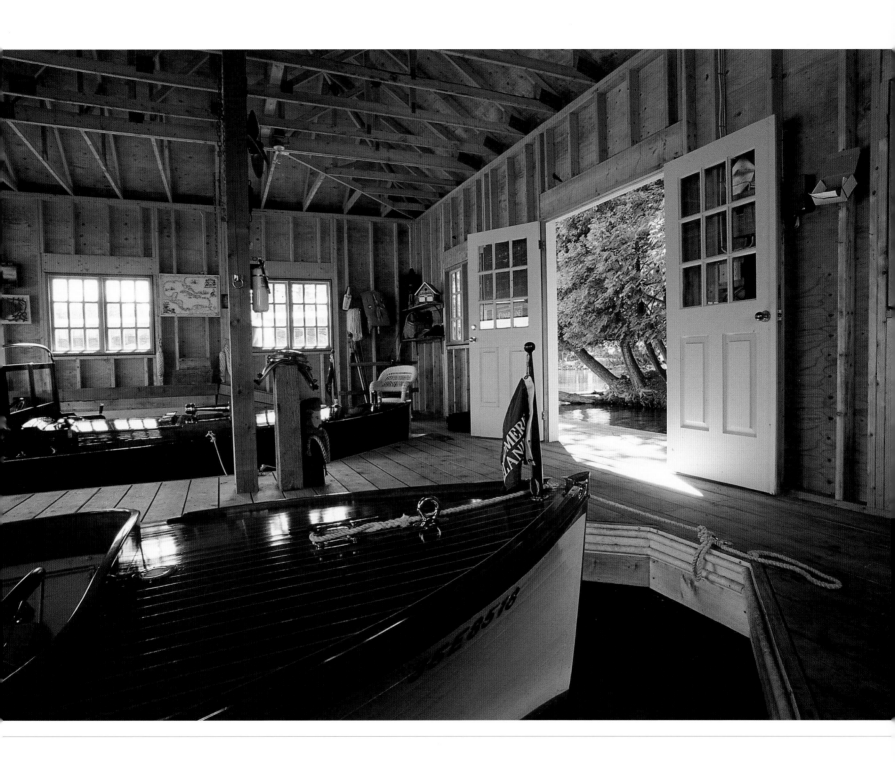

Two classic boats — the *Parthenia* and the *Woodmere*, a 1928 Ditchburn, occupy the new boathouse at Woodmere, built in 1993 by Port Carling contractor Wayne Dempsey.

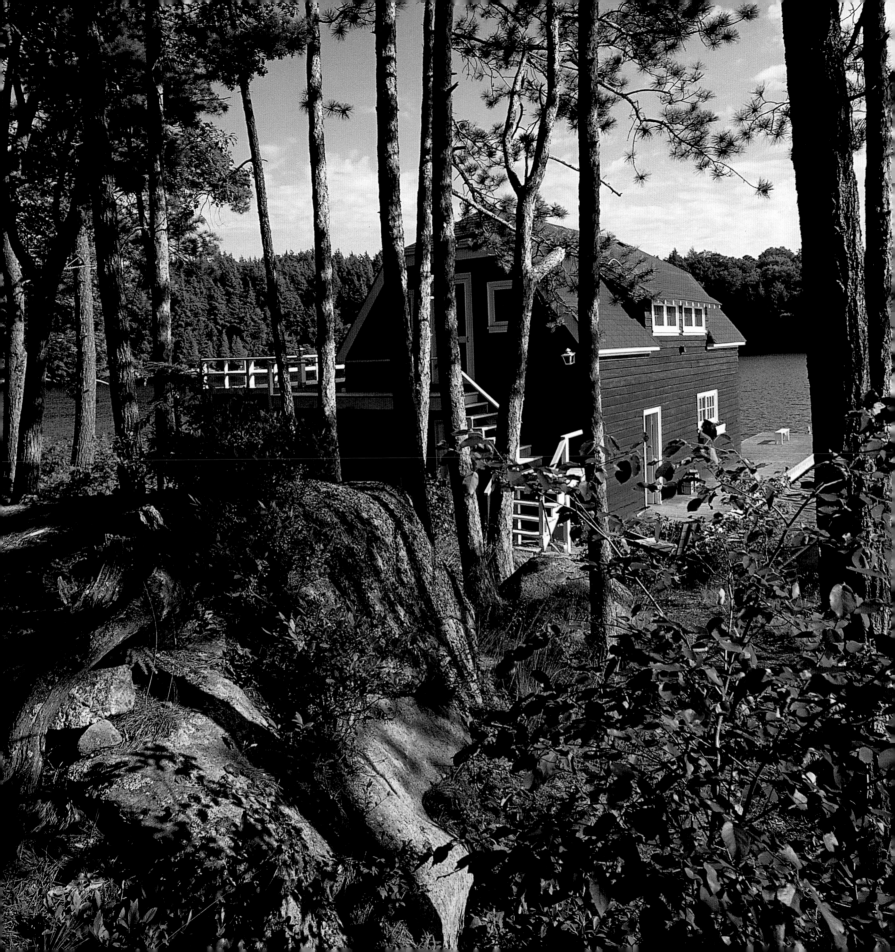

SUNNYSIDES

LAKE MUSKOKA

Chris Vandergrift and his wife, Jane Armstrong, had been looking for a cottage with a boathouse large enough to store their thirty-foot Duke cabin cruiser. In August 1997, when they pulled up to the dock at Keewaydin Island, the real estate sign was just being nailed up on a property with a classic old cottage and a boathouse with a thirty-four-foot slip. That was on Friday. By Monday they had bought the place. It was just what they were looking for.

"The nicest thing about it," says Chris, "is nothing had been done to alter the original cottage or boathouse. And both were built about 1927." The cottage has basswood-lined rooms, plenty of nooks and crannies, and every bedroom has a porcelain sink. The only necessary renovation was the cottage kitchen, which was original and charming with old wooden counters, but full of wood rot, so it had to be torn out.

In the boathouse, which also has the warm, woody smell of old cottages, only the bathroom needed redoing. It had been renovated in the 1950s and Chris wanted to return it to its original character. The porcelain sink was found under the cottage, probably discarded during the 1950s renovation. Everything else is exactly as it was when they moved in — the white-painted spool beds, the nautical touches such as boat lanterns turned into bedside lamps, the framed Muskoka maps on the wall.

They call their summer home Sunnysides because the property is at a narrow part of the large island, giving them frontage on both shores and sun all day long. The cottage faces east and the boathouse west. Two other identical boathouses were built on Keewaydin Island, all at the same time by a father for his three daughters. The other two have since enclosed the front balconies but otherwise maintain their classic character.

Keewaydin is the largest of a cluster of islands in northern Lake Muskoka known as the Seven Sisters. At one time, it was a port of call for the lake steamers and there was a summer post office here called Port Keewaydin. The island history is well documented in the photographs taken by Ed Hugil in the 1880s. Boaters cruising around the island today can still see many of the old boathouses captured in his photos.

For Chris and Jane, the island home is an ongoing pleasure. There is lots of space to store the antique boats that Chris has been collecting since 1986, including the wonderful *Crusoe,* the thirty-foot cabin cruiser built by Duke in Port Carling in 1952. And they still find treasures hidden in cupboards all over the cottage. Maybe it's not surprising when you buy a place with everything intact — "even peanut butter and jam still on the kitchen shelves."

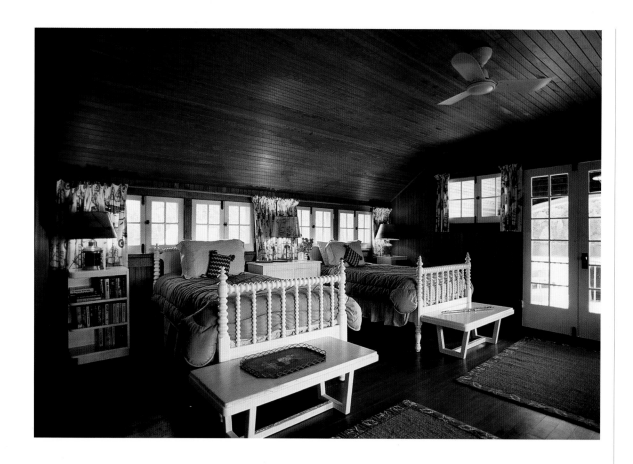

When the Vandergrifts bought the property, they acquired everything that was left behind, including the furniture, bedding and artifacts in the boathouse bedroom.

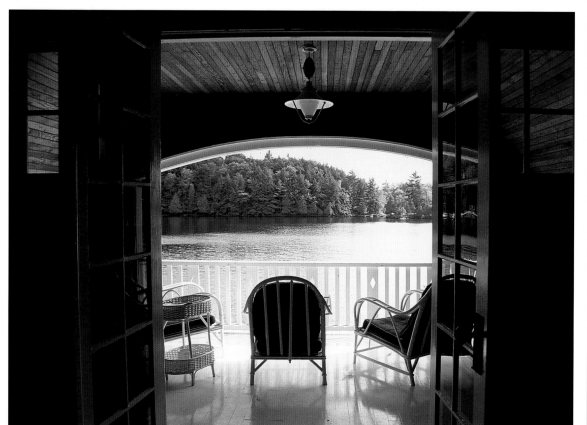

A peaceful view of neighboring islands from the covered verandah.

OVERLEAF:
Chris found the old porcelain sink under the cottage when he restored the boathouse bathroom. The antique toy car belonged to his wife, Jane.

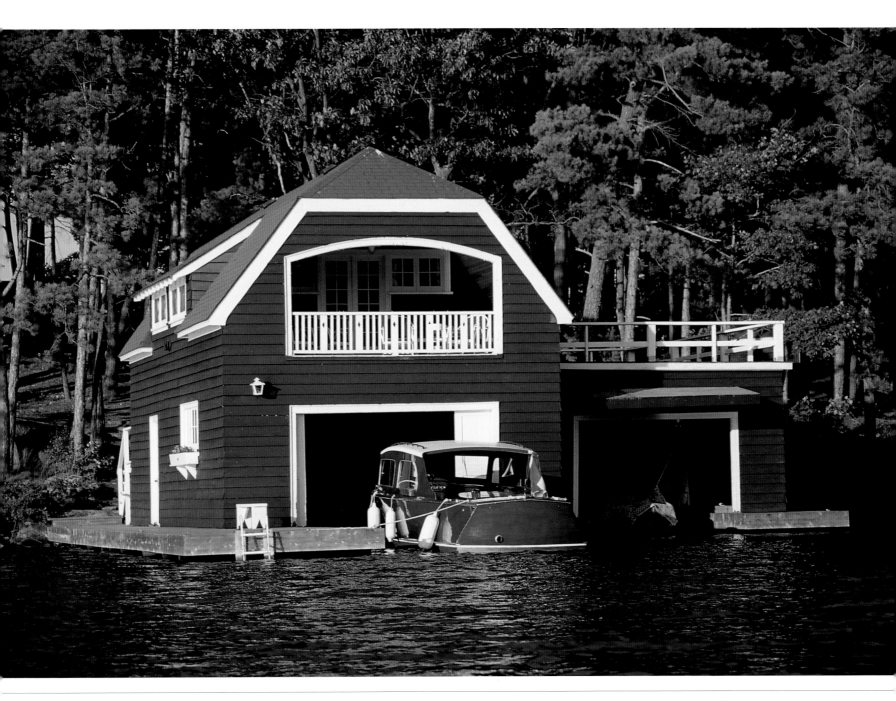

Chris Vandergrift bought the property on Keewaydin Island in 1997 mainly because the boathouse could accommodate *Crusoe*, his 1952 thirty-foot Duke cabin cruiser. The classic boathouse hasn't changed since it was built in 1927. Shed dormers in the hip roof feature the shaped rafters typical of Muskoka architecture at that time. A back staircase leads to the upper level and a double Dutch door.

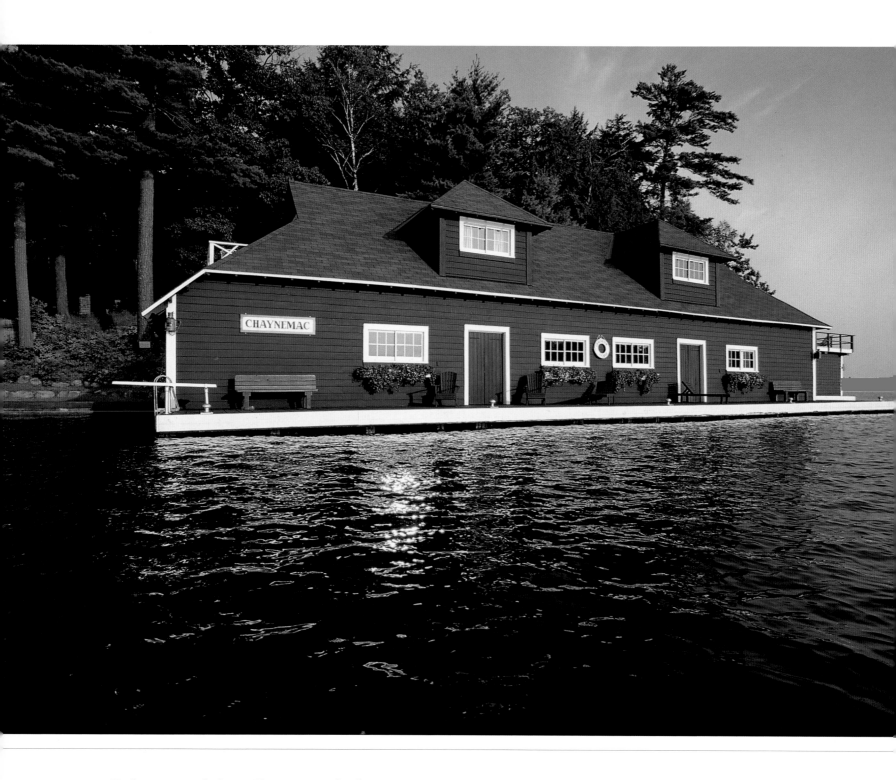

Early morning light at Chaynemac Island.

CHAYNEMAC

LAKE MUSKOKA

You can still see the charred ceiling beams in the two-story boathouse at Chaynemac. Back in the days when wood-burning engines fired the family steamboat *inside* the boathouse, such burn marks were common. It's no surprise that many of these buildings didn't survive the steamboat era.

The name Chaynemac originated in the early 1900s when the first owners of this five-acre island called each other by the nicknames "Chay" and "Mac." The new owners, Bill and Ann Deluce, have kept the name and the spirit of the vintage property. Since buying the island in 1994, they have worked hard to restore the serene character of the place, which was known for forty years as the Nelson Davis island. "When ninety-year-old Mrs. Davis came for tea last summer," says Ann, "I was pleased that she really liked what we had done."

Nelson and Eloise Davis bought the property in 1941 and owned it until 1981. Davis was a business tycoon who hobnobbed with the wealthy, including members of the Royal family. The Queen Mother reportedly was a guest on the island one summer, and her bedroom in a woodsy cabin near the water is preserved much as it was when she visited. Davis collected nautical and marine artifacts, and many of these are still intact, including old brass ship lanterns that light the wooded paths and antique marine charts rolled up in boathouse cupboards.

In the heyday of this picturesque island estate, Davis had sixteen boats housed in three separate boathouses. One of them, the *Chaynemac V,* was custom built for Davis by Greavette in 1947. The Deluces were able to buy it when they bought the island. The classic wooden launch still occupies a berth in one of the immense island boathouses.

Nelson Davis had a fulltime boat captain to attend to and operate his fleet. He lived above the boats in compact space still known as the captain's quarters. Today, the chart room still has the captain's old oak desk. Across the hallway is the bathroom, all freshly painted white but with the original light fixtures, sink, toilet and cast-iron tub on claw feet. In the bedroom, Mission-style twin beds are tucked beneath the sloping ceiling. The beds were made in the room during the winter months by the island caretaker. "They weigh so much they'll likely never be moved," says Ann. From the bedroom, doors open to a Juliette balcony with a wonderful view of Lake Muskoka.

The island is now an active, busy place in summer when Bill and Ann and their four children are in residence. Down at the boathouses, little has changed. The captain's quarters may look just as they did when Nelson Davis's boat chauffeur lived here, but now they're the summer digs of the Deluce's fifteen-year-old son.

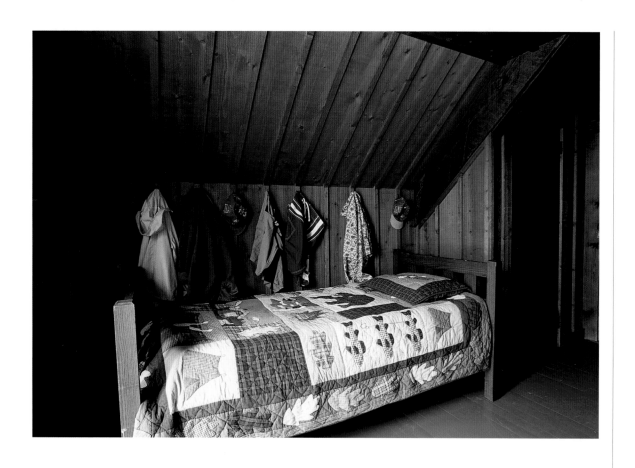

The bedroom in the second story of the boathouse has twin beds that were built there and will probably never leave.

The swimming house is well used by members of this family who gather for a daily swim around the five-acre island. This quaint little building is beside the old steamer dock. Stairs that allowed bathers to discreetly slide into the lake in the days when modesty was in fashion pull up when not in use. There's a sauna and changing room inside as well. The steamer dock is now used to tie up the Deluce's 1947 Beaver float plane.

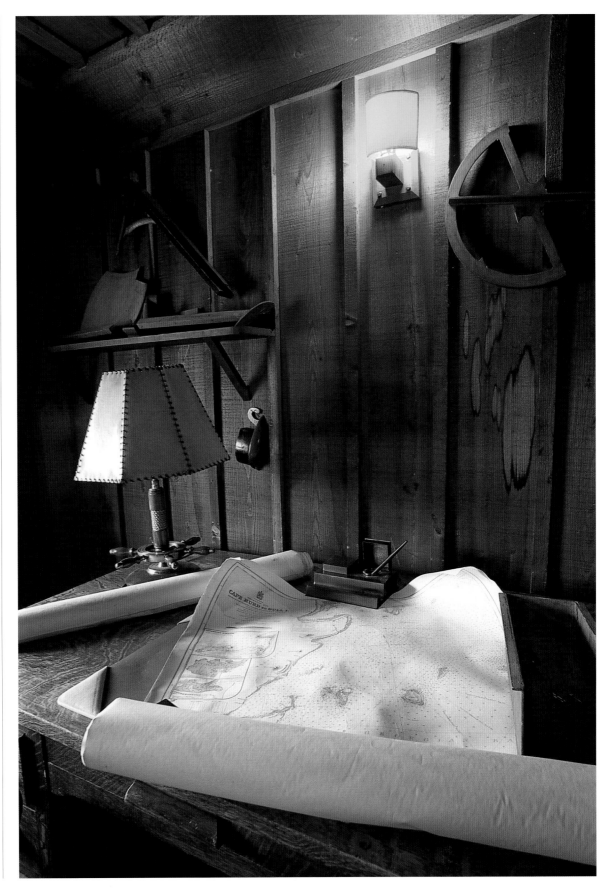

Old marine charts date back to the days when the estate's boat captain lived in the boathouse.

A complex hoist system of pulleys and chains makes opening and closing for the season a less daunting task.

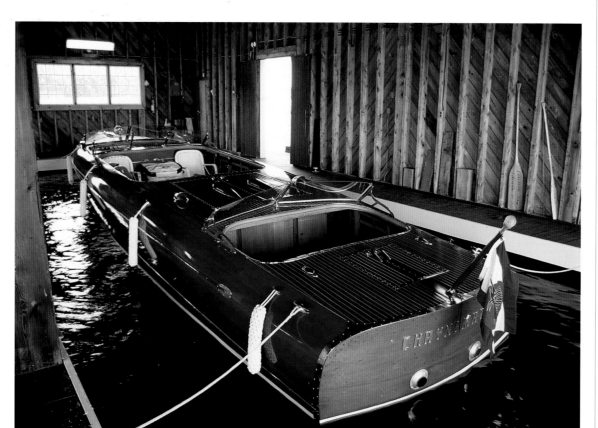

When the Deluce family go cruising in *Chaynemac V*, Ann's brother-in-law often sits in the "mother-in-law seat" and plays the bagpipes.

View from the boathouse deck at Chaynemac.

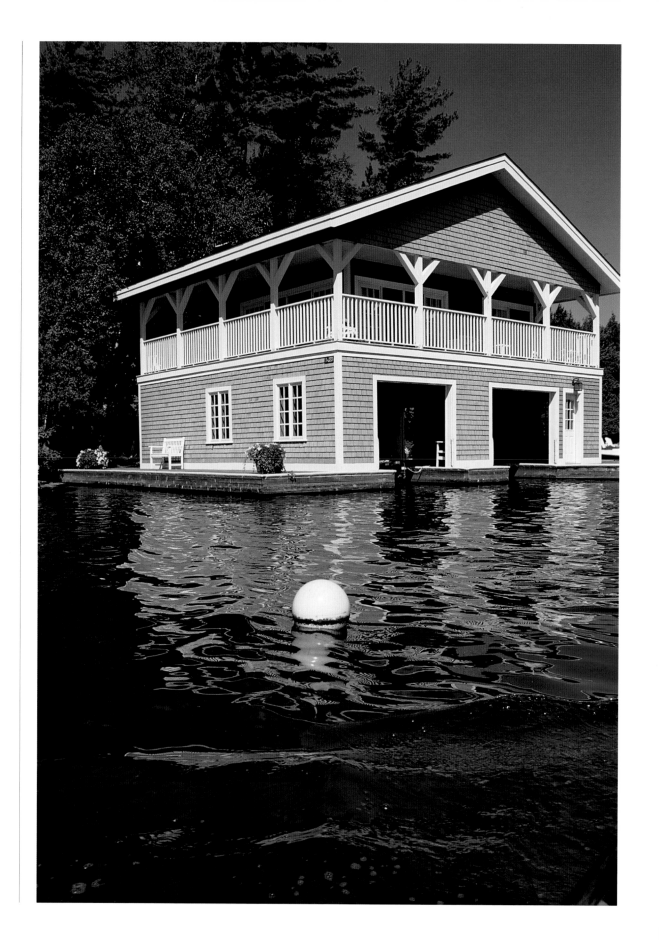

The graceful lines
of the boathouse
on Lyford Island
evoke the Quaker
aesthetic — spare
but visually strong.
Owner Sherry Eaton
worked with local
builder Brian
Humphrey on
the design.

LYFORD ISLAND

LAKE JOSEPH

It was only a few years ago that the pretty blue boathouse on Lyford Island was transformed from a plain, two-slip boathouse to this handsome structure with its wraparound verandah and jaunty white trim. The balance and symmetry of the style is reminiscent of a seaside house in New England. "I love the island of Nantucket and the homes there," says owner Sherry Eaton, "and perhaps that was in my mind when we were designing the boathouse."

Lyford Island was named after a Welsh colonel, possibly a relative of the original American owner who bought the two-acre island in 1903 for one dollar. It remained in his family until Sherry bought it in 1989. The name Lyford didn't catch on with the locals, though — they called it Goat Island because, years ago, a mainland farmer used to bring his goat herd here to graze. It may be that the goats are the reason for the lovely swaths of exposed granite that now define the island landscape.

"I spent many years in Georgian Bay," says Sherry, "and this island reminded me of that area with its flat rock and low profile. I liked the fact that there were no steep hills, no bad sides or dark views. And all the bedrooms in the cottage have a view of water." She admits, though, that none are as luminous as the light-filled boathouse. Some day, she contends, she may move out of the cottage and into the boathouse herself.

For now, it's a soothing space for guests, as welcoming as any luxurious country inn with its freshly cut flowers, fine toiletries and soft bed-linens. The king-size bed is positioned to take advantage of the sparkling views of lake water. Two walls are composed of oversized multipaned glass doors that slide open to the covered porch. Overhead, in the vaulted ceiling, there are glass panels in the gables that offer a glimpse into the treetops. Wicker chairs on the porch face a tiny island inhabited only by birds residing in a twig birdhouse.

Sherry consulted decorating contractor David Bermann of Scandinavian Painting Inc. in Toronto for advice on the boathouse interior. Both agreed that the interior should be kept neutral — that there's no sense in competing with nature in such a setting. The wide plank pine walls (smooth side facing out) were treated with layers of knot sealer and primer to prevent the knots and resin from bleeding through, and then painted in a creamy off-white. "The idea was to keep everything light and airy," says David, "so that all the color comes from the lake and the trees."

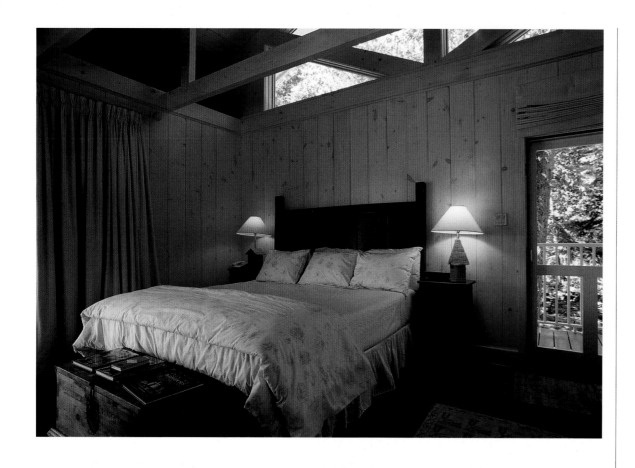

Birdhouses — seen here in the form of bedside lamps — are a recurrent theme on this island. Toby Schertzer of DIN Studios made the headboard, and many of the interior finishing ideas came from decorating contractor David Bermann.

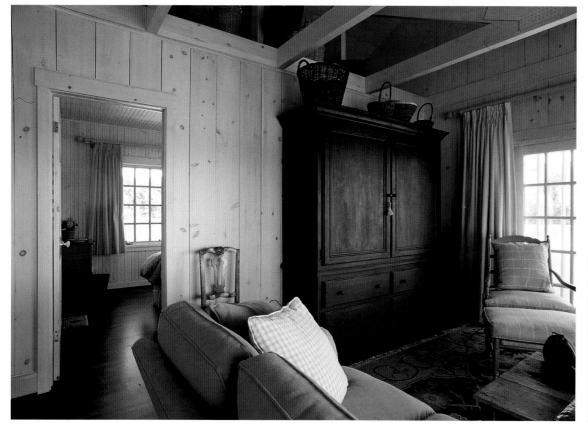

Splashes of red, blue and yellow brighten the mostly neutral interior. Watered-down white stain was applied to the pine wallboards to lighten the wood color.

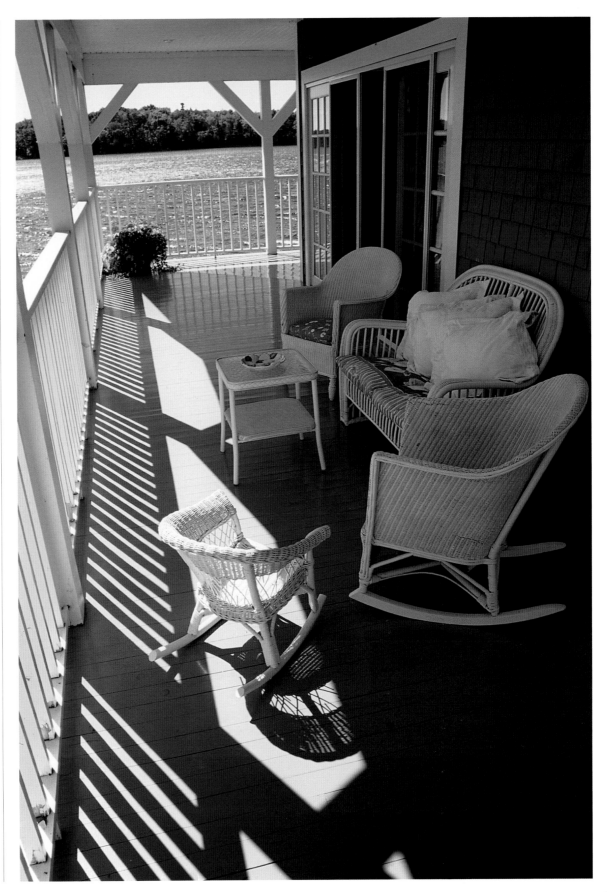

A covered porch wraps around two sides, offering protection from wind and sun all day long.

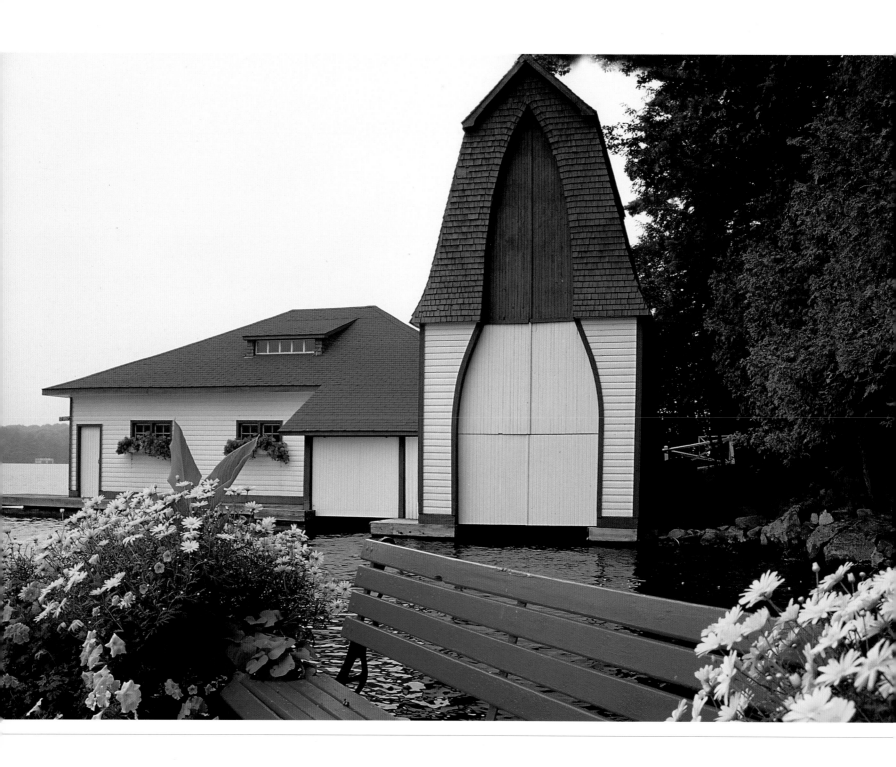

Ouno Island's eyecatching sailboat boathouse, built in 1915, as seen from the steamer dock.

OUNO ISLAND

LAKE ROSSEAU

Every weekend for fifteen months, Valerie and Eric Grundy scoured the lakes of Muskoka and the Kawarthas with real estate agents looking for a cottage property. When they landed at Ouno Island on Lake Rosseau, they both knew immediately that their search had ended. "It just felt good," says Eric simply.

The property, which they bought in 1994, sprawls across a lovely low sweep of shoreline on the twenty-two-acre island. On a gentle hilltop sits the classic two-story cottage with gabled sleeping porches and wood-lined rooms. Its stone walkways lead to the large steamer dock and the boathouses. One two-story boathouse, built around 1900, was the first building on the island. At the time, it was used to store the canoes and rowboats that were the only means of water transportation. The upper level is now one large bedroom that opens onto a covered verandah. The other Ouno Island boathouse is something of a landmark on the lake.

Boats slow as they pass by the green and yellow sailboat boathouse — a unique structure attached at a ninety-degree angle to the three-slip launch house. It was built in 1915 by James Hardy, the island owner of the time and a founder of the Muskoka Lakes Golf and Country Club. He wanted to shelter his thirty-foot sloop, which was designed and built by Bert Minett, a famous Muskoka boatbuilder.

The building rises torpedo-like to a narrow peak with clearance for a thirty-five-foot mast. The door consists of three sections that open inward, but opening them is not easy. The two upper sections open on a pulley system. However, each of the three sections is kept shut by a wooden crossbar. So someone has to climb the ladder that spans one curving wall and, using a long pole for leverage, remove the crossbars from their latches. The boat that now occupies the single slip is the *Trillium*, the Grundys' twenty-foot Niad daysailer. "We love to sail, so we usually leave these doors open all summer," Eric explains, "just because it's such a difficult chore."

Over at the century-old dry-slip boathouse, the Grundys have converted storage space into a sparkling fitness room with polished wooden floors, a sound system and bar fridge. They love being able to slide open the barn doors, work out on the treadmill and gaze out at the lake. The doors open to a floating platform, where once rowboats and canoes would have been pulled out of the water on wooden rollers. It now supports two Thai lounge chairs where Eric and Valerie relax after their workouts and remind themselves that, despite "seven years of hard labor," Ouno Island with its quaint old buildings is still a great place to be.

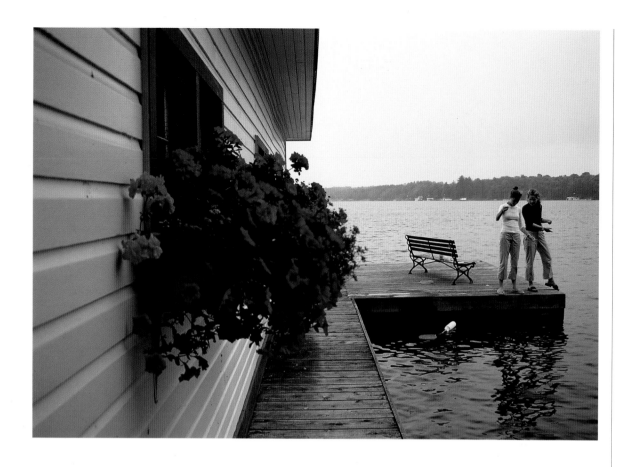

Valerie Grundy's window boxes and planters earned high praise at the Muskoka Heritage Foundation's Garden Tour.

The Grundys turned the downstairs of the dryland boathouse into a fitness room. Being right on the water makes it ideal for post-workout dips in the lake.

OVERLEAF:
The interior is an intricate latticework of beams and rafters with pulleys for opening the three door sections.

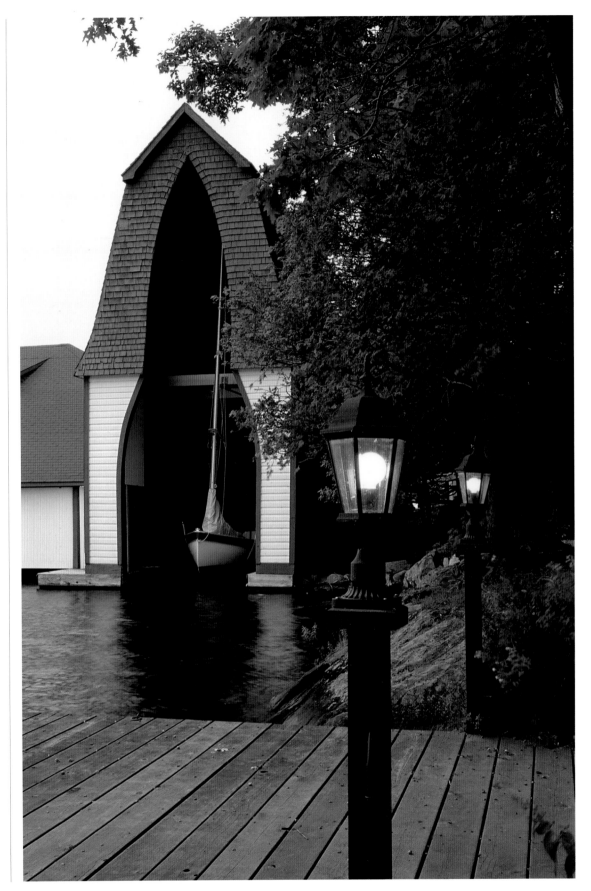

This sailboat boathouse is an unusual sight in Muskoka. It was built in 1915 to accommodate a thirty-foot sloop. Two other sailboat boathouses exist on Lake Rosseau, both of them built in 1935 for the Osler family.

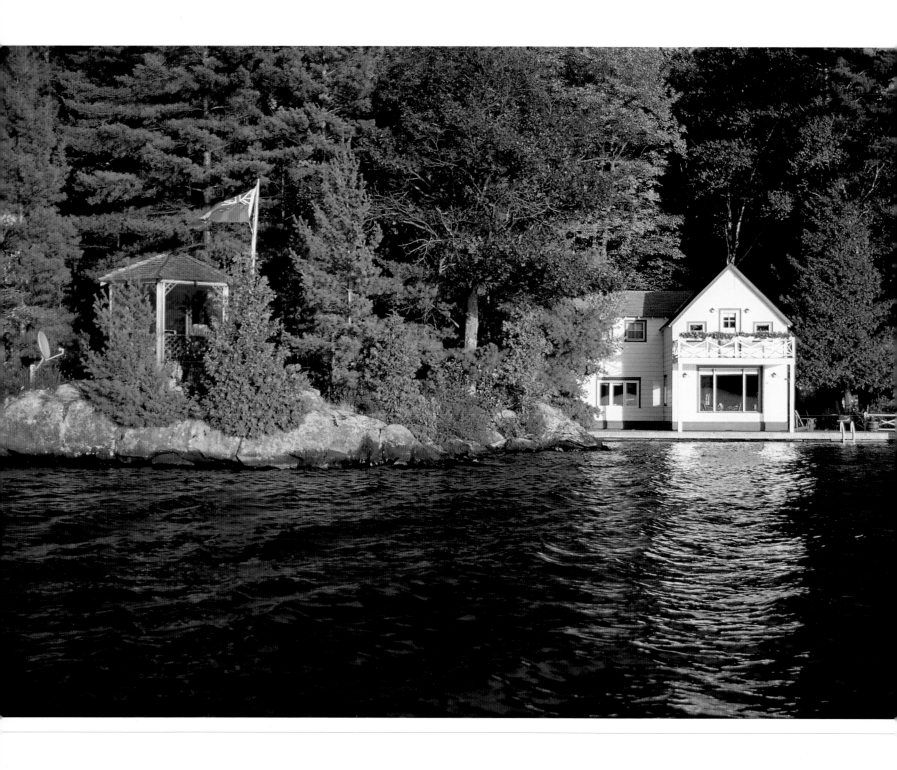

Donald and Margaret Hewgill's boathouse cottage basks in the glow of sunset.

HORSESHOE ISLAND

LAKE MUSKOKA

In the tenets of Japanese architecture, it is important to live lightly on the land. At Horseshoe Island, Donald and Margaret Hewgill do just that. Their cottage is a small boathouse tucked in a bay on this most northerly of Lake Muskoka's islands. It is quite unlike other Muskoka boathouses. There are no cupolas, no broad decks, no fancy fretwork, not even a boat slip, because it originated as a dry boathouse. This simple clapboard structure with its peak roof and small balcony sits gently on cribs at the shore. Only the back kitchen is on land, occupying a tiny chunk of waterfront. Little has changed here in almost a hundred years.

The boathouse was originally built in 1905 to store canoes and rowboats. When Don's uncle bought Horseshoe Island in 1949, it was the only building, apart from an icehouse out back. Rather than construct something new, he merely converted the boathouse into living quarters, with one large bedroom in the upper level. Later, he added a den with a fireplace on the building's north side. Where double wooden doors once opened onto the boat ramp, he put in a large picture window facing west toward the Indian River.

Don inherited the property from his uncle in 1965 — "a very pleasant surprise," he adds — and continues to maintain the boathouse much as it always was. A few years back he had to jack the whole place up and replace the cribbing. He also built a fanciful gazebo on the point where he and Marg sit and watch the setting sun. But like his uncle, he has resisted expansion, adding only the back kitchen in 1968. When more space was required, he worked within the framework and chopped up the existing interior. The upstairs bedroom was subdivided over and over again. Marg laughs as she meanders through the rabbit warren of rooms. "Now we have four bedrooms and two bathrooms up here. We use every inch of space." Even the tin-lined closet built originally to keep bed linens and blankets free from mice has been converted to a room with bunk beds for the grandchildren. At times, when all the family are together, eleven of them coexist here. "That's when Marg and I go and sleep in the icehouse," says Don. "It's an all-purpose room now, a storage, bunkie and junk room."

Today, the Hewgill's boathouse has the casual affectionate atmosphere of a well-used family cottage. Surrounding it are untouched swaths of Muskoka landscape and beautiful pristine shoreline. From the water, when the long rays of the setting sun bathe the boathouse in golden light, it seems to float there — as lightly on the land as humanly possible.

The pine-paneled kitchen was added to the back of the original building.

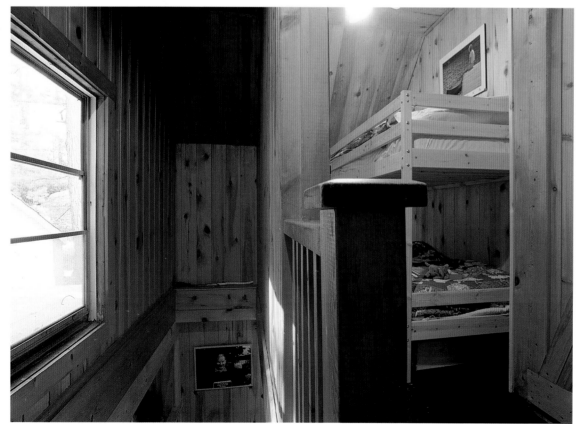

A tin-lined closet becomes a bunk bedroom for the grandchildren.

Stairs lead to the second story and a maze of tiny bedrooms.

The boat doors of the dryland boathouse were removed and a large picture window has taken their place.

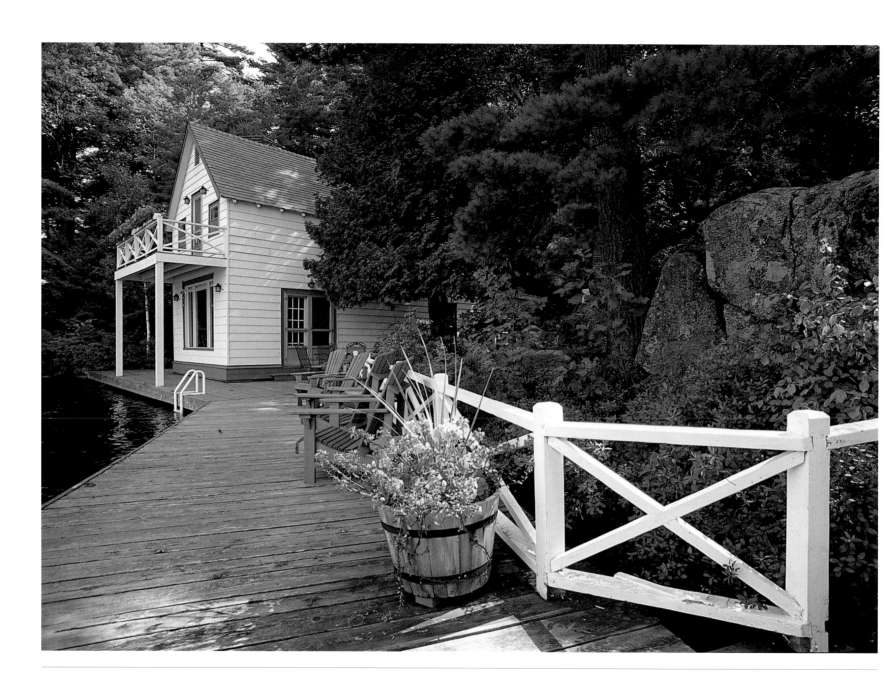

New docks wrap around the shoreline.

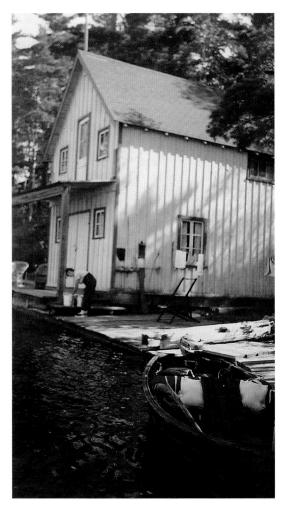

Built in 1905 as a dryland boathouse, the original structure has been maintained with just a few modern additions over the years.

The icehouse, where food was kept cold with large chunks of lake ice in sawdust, is now a bunkie and storage room.

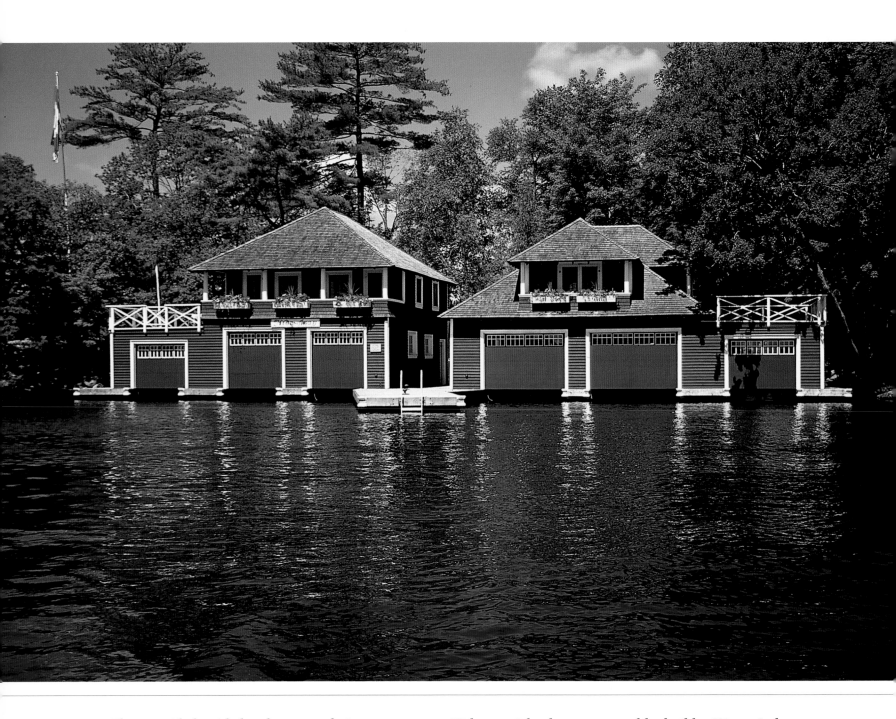

The two side-by-side boathouses and vintage cottage on Hideaway Island were restored by builder Wayne Judges. "This is my favorite kind of work," he says. "Sometimes it would be easier to tear down the old structures and build new, but you never get the same feeling. Also, you'd never be able to build this way again. The cottage is closer to the water than allowed today — and each boathouse has about a thousand square feet of living space."

HIDEAWAY ISLAND

LAKE ROSSEAU

When the current owners bought Hideaway Island in 1998, with its vast old cottage and twin boathouses, they were taking over a much-loved retreat that had been in the same family for almost thirty years. It had fallen sadly into disrepair. When the scrupulous restoration was almost complete, the son of the former owners returned. He wrote a moving letter describing his family's emotional ties to the island and his pleasure at seeing such "a beautiful and thoughtful restoration." His framed letter hangs in the kitchen of the turn-of-the-century cottage.

This is just one indication of the care that went into the revival of this lovely Muskoka property. Working with builder Wayne Judges, the new owners wanted to update everything without destroying the integrity of the original structures. "We believe that the first building on the island was constructed in 1876," says the new owner. "We know for sure that the main cottage was here in 1887 because that date and the owner's name, 'Mildred Cartwright,' are etched in a window pane. We think she did it with her diamond ring."

The renovation has been an all-consuming task. Even the legendary perennial gardens, tended for decades by the former owner, were preserved. All the plant material was moved to the far side of the island during the construction and then replanted in its original bed. The fun part has been finding treasures in cupboards (old woolen blankets, table linens and monogrammed bed sheets) and piecing together the island history from old newspapers found inside the walls. A 1905 copy of the *Mail and Empire* (an early version of the *Globe and Mail*) was found in one boathouse when the builders were tearing out the fiberboard walls.

There are two matching three-slip boathouses at Hideaway. One is divided upstairs into two dormitory-style bedrooms (a green room for girls and a blue room for boys). Both have separate entrances up a back staircase and doors at the lake end that open onto a common verandah. The upper level of the second boathouse is a party room for the family's three teenage daughters. Neither boathouse has plumbing. Instead, handpainted signs point the way to the Ladies and Gents washrooms and a shower house (his and hers also) tucked away in the woods.

Whenever possible, old furniture has been freshened with new paint, cabinet hardware cleaned up and reused, and bathroom fixtures restored or replaced with antique fittings from the same era. All in all, it feels and looks very much the way it did in the summer of 1887 when Mildred Cartwright decided to leave her permanent imprint.

Bathrobes are supplied
for the trek to the shower house.

Regatta prowess displayed
on the basswood walls.

The girls' bedroom, built for the family's three teenage daughters. Upstairs in the second boathouse there's a party room — "just for hanging out."

The boys' bedroom, with its neat row of beds. Most of the furniture was in the boathouse or cottage and required just a fresh coat of paint.

The old cedar-strip canoe, *Hideaway*, was a house gift from friends. The biggest challenge with the boathouses was tearing out and replacing the old docks. They were interconnected, originally built as one big dock, so both buildings had to be raised at the same time.

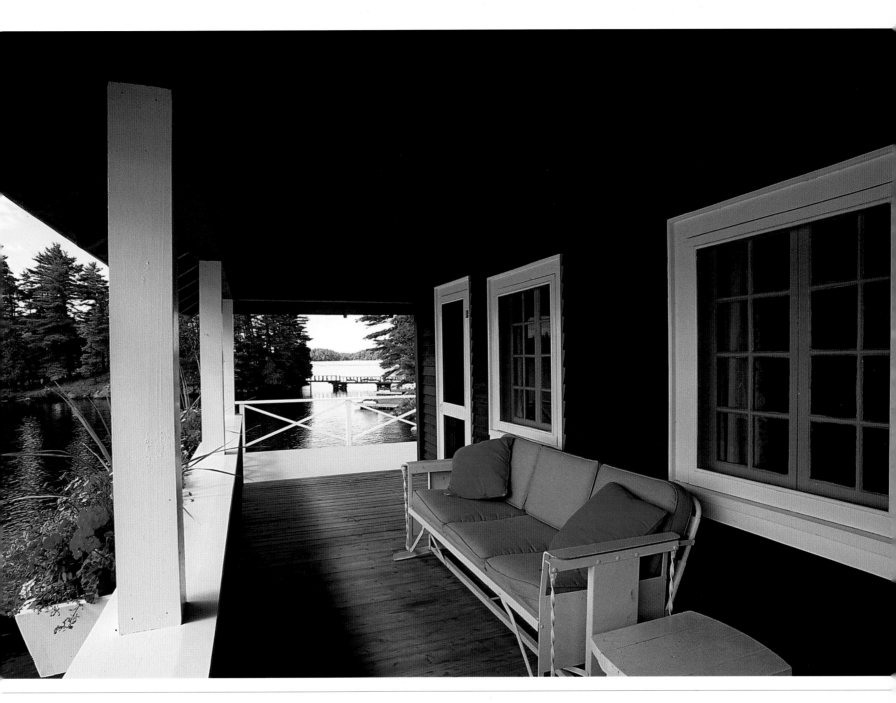

Who can resist a swing on the old-fashioned porch sofa that glides on metal runners? From the covered verandah, doors open into the two separate bedrooms. In the distance, a wooden bridge leads to the half-acre island where the original cottage was built. An automatic sprinkler system snakes its way through the lushly planted window boxes, containers and flower beds on the island.

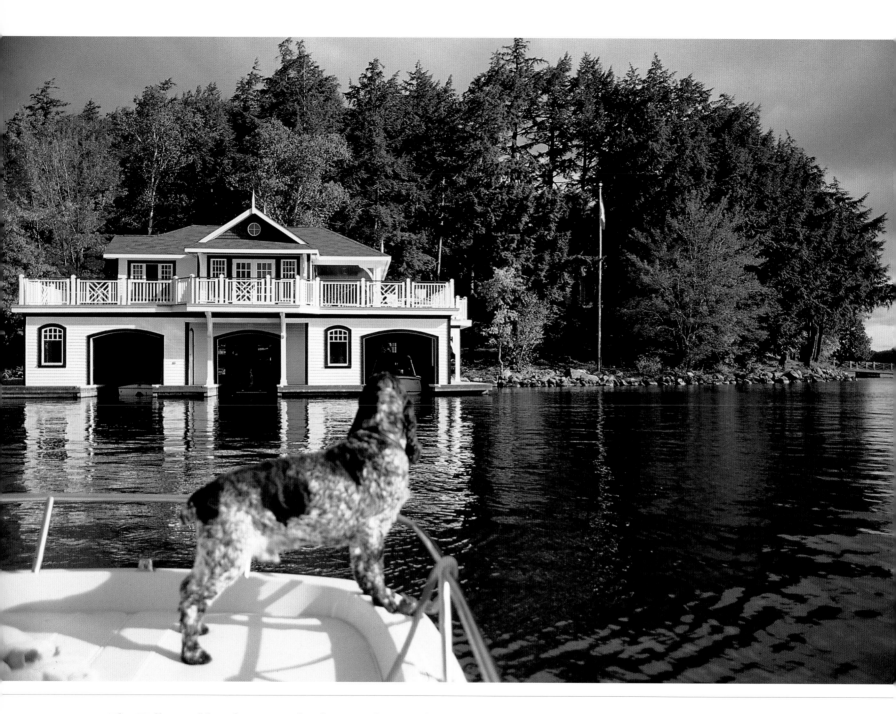

The Willowood boathouse used to be a single-story building with a flat, pea-gravel roof. Inside were massive squared-off ceiling beams used for hauling up boats before freeze-up. These were left intact. The exterior, however, has been totally changed. Architect David Gillett took advantage of the lovely setting to design a handsome boathouse in keeping with the 1920s cottage. He added verandahs, columns and overhangs but avoided any excess ornamentation.

WILLOWOOD

LAKE ROSSEAU

I wanted to capture summertime," says Michele Young. "Whenever I walk into this boathouse, I want it to feel like July twentieth."

Michele, her husband, Gordon, and their three children moved into this wooded property on Lake Rosseau in 1998. It had been the summer home of Gordon's parents for thirty years — the name "Willowood" a compilation of their names, William and Lois, and Wood for the street where they lived in Toronto. Michele and Gordon are still in the process of making it a place of their own.

When they decided to add living quarters to the boathouse, they chose to complement the style of the 1920s cottage, with its verandahs, columns and mullioned windows. The boathouse had been simply a flat-topped garage for boats with two enclosed slips and a boat port. Architect David Gillett was hired to convert it to a two-story, three-slip boathouse.

"The boathouse setting is somewhat unique," says David. "The shore side is clearly visible from the cottage, so we had to make it as attractive as the lake side."

A wide flagstone path and stairway lead down a gentle slope to the boathouse. An arched canopy and elaborate woodworking details add interest, and the entry door, designed by Michele, is more welcoming than an ordinary utility door. The second story has mullioned windows on all sides. For the water view, the architect's goal was to keep the boathouse from looking like a three-car garage. To achieve this, he recessed the middle boat door to effectively lessen the bulk of the structure.

The interior has a breezy barefoot comfort. Rough-sawn plank walls are painted white and light dances in from all sides. Although it measures only the mandatory 650 square feet, it gives the illusion of more space. There's an ample country-style kitchen and sitting room with white slip-covered sofas and two bedrooms with fresh blue and white linens. Michele adds dashes of color throughout with her own acrylic paintings. She loves nooks and crannies, "the more the better," she says — witness her snug design for the bunk bedroom.

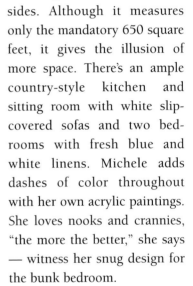

Each of the bunk beds has a double mattress on a built-in platform, tall enough to sit down and not hit your head. The design, with cabinetry by local craftsman Chris Goneau, includes some space-saving measures perfected by boatwrights. Cubbyholes at the headboard lift up for storing books, a reading light hangs overhead, and each bed has its own tiny window with curtains that pull across for privacy. But unlike portholes on ships, these windows open to let in the fresh lake breezes.

Guests who stay in the boathouse fall in love with the sunwashed space that is luminous even on gray days. Just as Michele had hoped, it always feels like summertime.

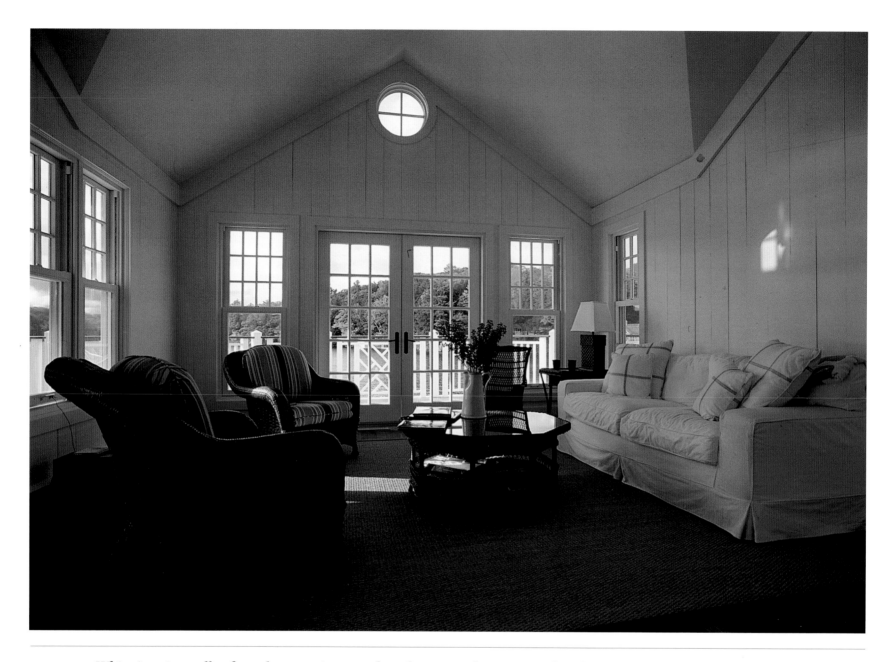

White interior walls of rough-sawn pine are a key element in the summery beach house look that Michele Young prefers. Cottage blues and splashes of bright red add color. The floors are easy-care prefinished Brazilian mahogany. White slipcovers on the sofas may seem foolhardy with three children, but Michele claims "they're easy because they can be washed."

OVERLEAF: The kitchen was designed to look old-fashioned, with painted wooden cabinets, chrome fittings and open shelves. A collection of blue-and-white china adds color to the white plank walls.

The design for the bunk
bedroom was created
with a ship in mind.
Everything is built-in,
compact and well crafted.

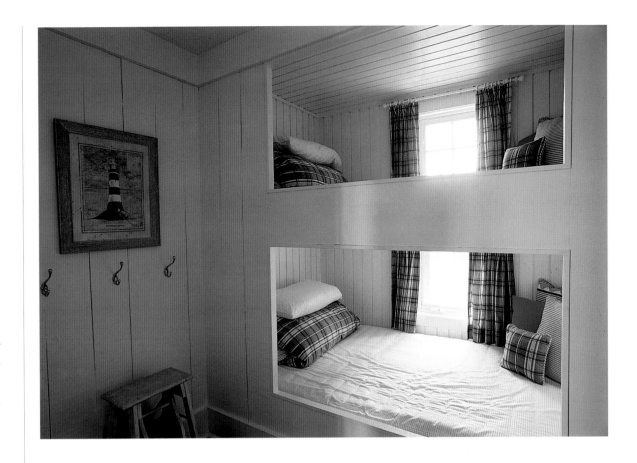

A generous helping of
white keeps the interior
sunny even on overcast
days. One of Michele's
acrylic paintings is
propped on the
headboard.

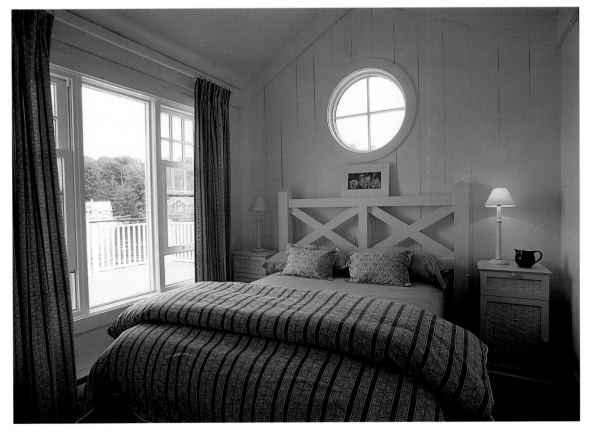

139

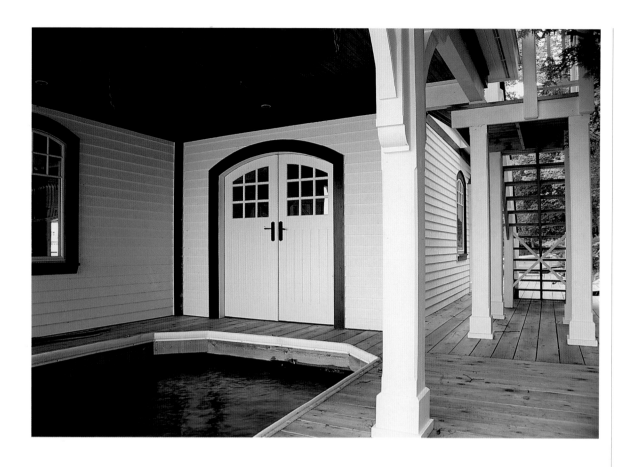

The boat port provides extra moorage and the stairway leads to the spacious deck.

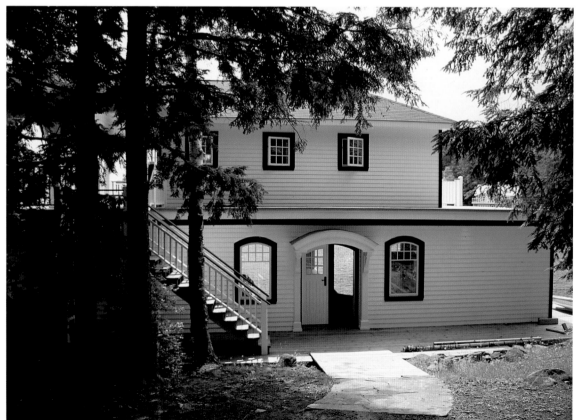

The land side of the boathouse received equal attention because of its visibility from the cottage. A wide flagstone path leads to an entranceway with an arched canopy and wooden columns.

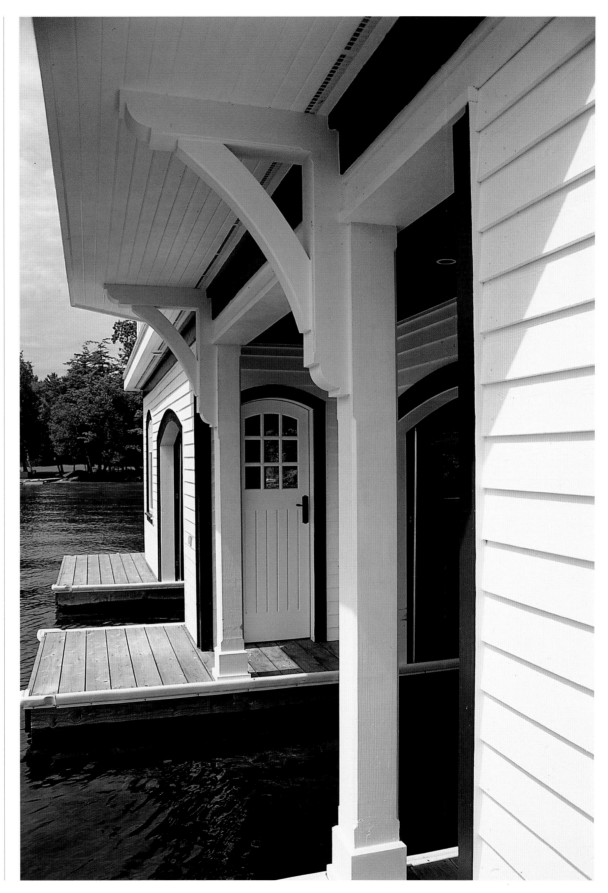

The middle boat door was recessed to keep the boathouse from looking like a three-car garage.

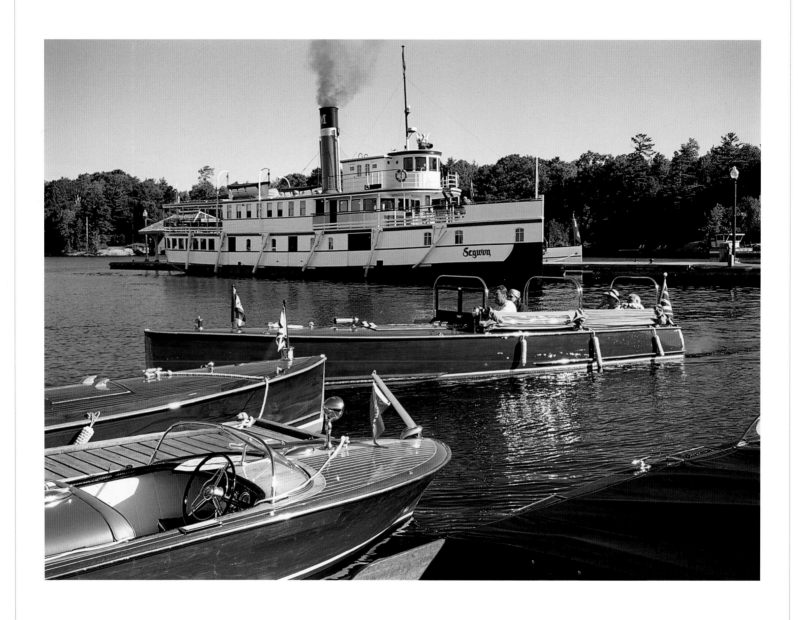

Every July, antique boats rumble out of their private boathouses
to appear at the Antique & Classic Boat Show in Gravenhurst.
It's the largest in-water boat display in Canada. The star of the show,
as always, is the R.M.S. *Segwun*, a 113-year-old steamship.

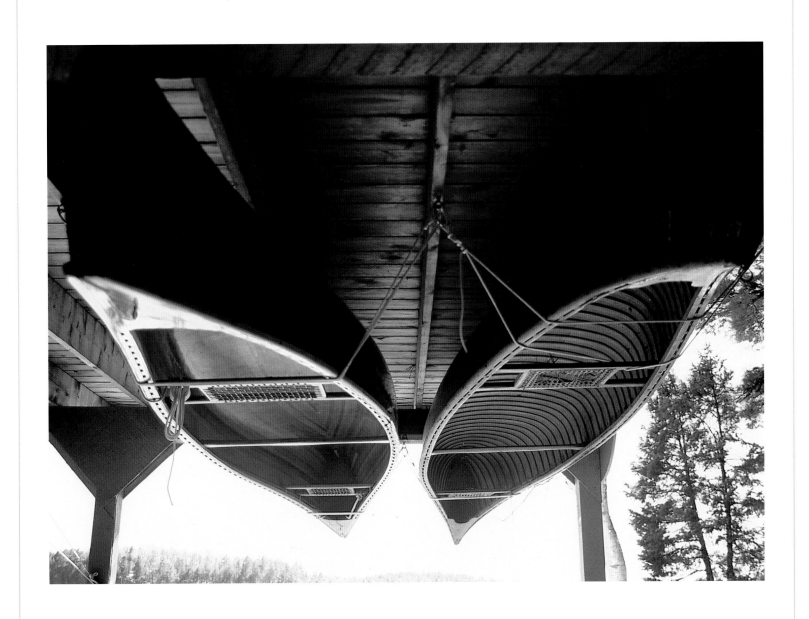

Even canoes are put to rest at summer's end.

Winter — the quiet season. Boathouses sit idle in the frozen lake.
Inside, boats have been hoisted above the lake surface to await the arrival of spring.